POLICE
PICTURES

· · · · · · · · · · · · · · · ·

The
Photograph
as
Evidence

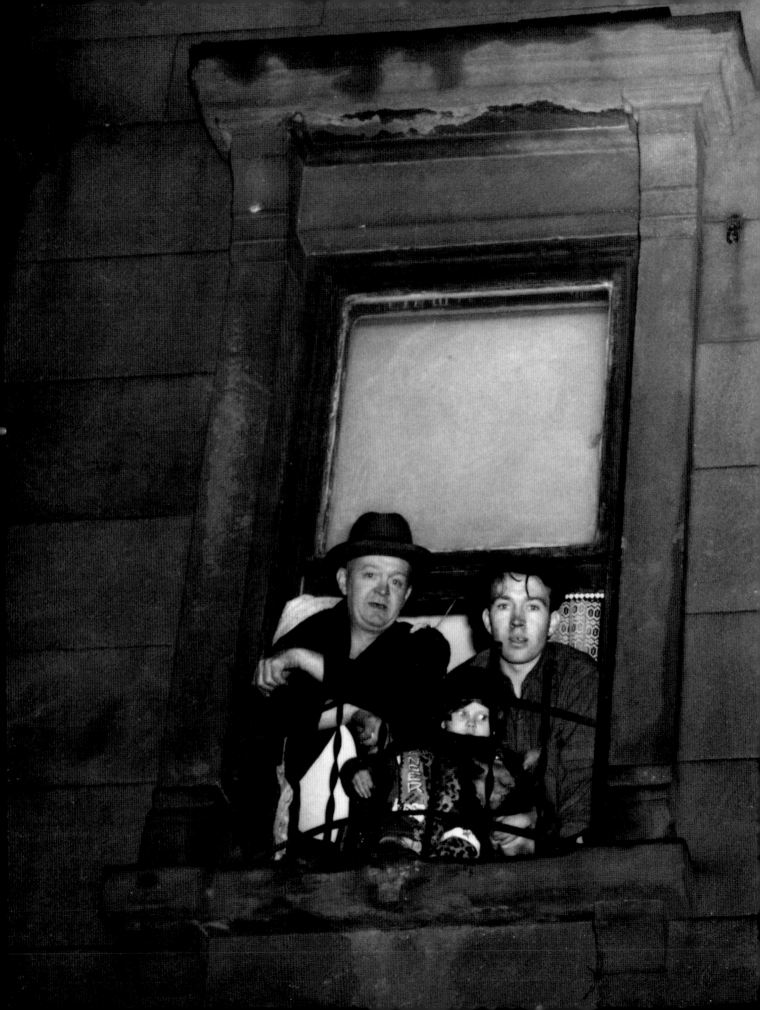

POLICE PICTURES

The

Photograph

as

Evidence

Sandra S. Phillips

Mark Haworth-Booth

Carol Squiers

SAN FRANCISCO MUSEUM OF MODERN ART · CHRONICLE BOOKS, SAN FRANCISCO

This catalogue is published on the occasion of the exhibition *Police Pictures: The Photograph as Evidence,* organized by Sandra S. Phillips at the San Francisco Museum of Modern Art. *Police Pictures: The Photograph as Evidence* is made possible by the National Endowment for the Arts, a Federal agency. Additional support is generously provided by Frances and John Bowes; Mrs. Walter A. Haas, Jr.; and Pat and Bill Wilson.

EXHIBITION SCHEDULE

San Francisco Museum of Modern Art
October 17, 1997–January 20, 1998

Grey Art Gallery and Study Center at New York University
May 19–July 18, 1998

This volume is copublished by the San Francisco Museum of Modern Art and Chronicle Books, 85 Second Street, San Francisco, CA 94105, www.chronbooks.com.

Distributed in Canada by Raincoast Books, 8680 Cambie Street, Vancouver, B.C. V6P 6M9

10 9 8 7 6 5 4 3 2 1

Publication Manager: Kara Kirk
Designer: Michael Sumner/Burning Books
Editors: Genoa Shepley and Melody Sumner Carnahan
Photography Coordinator: Alexandra Chappell

FRONT COVER
Detail of plate 30:
Unknown
Hand of Ching See Foo , the Chinese Strangler Shot in Frisco in 1893, 1893
Courtesy of Stephen Wirtz Gallery, San Francisco

BACK COVER
Plate 70:
Unknown
Bonnie Parker, the Gun Moll of the 1930's, n.d.
Collection of Stanley B. Burns, M.D., and the Burns Archive

FRONTISPIECE
Detail of original found on page 9:
Weegee (Arthur Fellig)
Murder in Hell's Kitchen, ca. 1940
Collection of the International Center of Photography, New York.
Bequest of Wilma Wilcox

Library of Congress Cataloging-in-Publication Data:

Phillips, Sandra S., 1945–
 Police pictures : the photograph as evidence / Sandra S. Phillips, Mark
 Haworth-Booth, and Carol Squiers.
 p. cm.
 Catalogue published on the occasion of the exhibition on view at the
 San Francisco Museum of Modern Art, Oct. 17, 1997–Jan. 20, 1998.
 ISBN 0-8118-1984-1
 1. Criminals—Portraits—Exhibitions. 2. Criminal anthropology—
 Exhibitions. 3. Criminal investigation—Exhibitions. 4. Photography—
 Exhibitions. I. Haworth-Booth, Mark. II. Squiers, Carol, 1948–.
 III. San Francisco Museum of Modern Art. IV. Title.
 HV6071.P48 1997
 363.25'8—dc21 97-14539
 CIP

Printed and bound in Italy

PHOTOGRAPHY CREDITS

Unless otherwise indicated below, illustrations have been supplied by the owner of the work named in the caption.

FRONT COVER: Photo by Ian Reeves.

BACK COVER: Photo courtesy of Corbis-Bettmann.

FRONTISPIECE AND PAGE 9: © 1994 International Center of Photography, New York. Bequest of Wilma Wilcox.

FIGURES
Figures 2–4, 7–8: photo by Ian Reeves; figs. 9–10: photo by Ben Blackwell; fig. 11: © 1997 Andy Warhol Foundation for the Visual Arts/ARS, New York; fig. 12: © 1994 International Center of Photography, New York. Bequest of Wilma Wilcox; fig. 15: © New York Daily News, L.P., reprinted with permission.

PLATES
Plates 2–5: photo by Hillel Burger, © 1978 President and Fellows of Harvard College; pls. 10, 12: photo by Ben Blackwell; pl 16: photo courtesy of the California Historical Society, San Francisco. FN-30674; pls. 23, 30: photo by Ben Blackwell; pl. 32: photo courtesy of the California Historical Society Library, San Francisco. FN-30676; pl. 37: photo by Ben Blackwell; pl. 38, 40: photo by Doug Hall Photography; pl. 41–44, 47: photo by Ben Blackwell; pl. 61: photo courtesy of the California Historical Society, San Francisco. FN-30675; pl. 63: photo by Ben Blackwell; pl. 64: photo by Adam Reich; pl. 65: courtesy of UPI/Corbis-Bettmann; pl. 69: photo by Ben Blackwell; pl. 70: photo courtesy Corbis-Bettmann; pl. 71: photo courtesy of UPI/Corbis-Bettmann; pls. 72–74: © 1994 International Center of Photography, New York. Bequest of Wilma Wilcox, photo by Ben Blackwell; pl. 77: photo by Ben Blackwell; pls. 79–80: © 1944 Harold Edgerton, courtesy of Palm Press, Inc.; pls. 81–82: photo by Ben Blackwell; pl. 85: courtesy of the National Archives, Washington, D.C. (photo number 65-CC-17); pl. 86: photo by Ben Blackwell; pl. 87: photo courtesy of Dave Gatley; pl. 88: courtesy of UPI/Corbis-Bettmann, photo by Ben Blackwell; pl. 89: photo by Ben Blackwell; pl. 90: © Time Inc., reprinted with permission, photo by Ben Blackwell; pls. 91–94: photo by Ben Blackwell.

CONTENTS

· · · · · · · · ·

6 LENDERS TO THE EXHIBITION

7 FOREWORD AND ACKNOWLEDGMENTS
 Lori Fogarty

11 IDENTIFYING THE CRIMINAL
 Sandra S. Phillips

33 "A CAMERA EYE AS RARE AS A PINK ZEBRA"
 Mark Haworth-Booth

41 "AND SO THE MOVING TRIGGER FINGER WRITES":
 DEAD GANGSTERS AND NEW YORK TABLOIDS IN THE 1930S
 Carol Squiers

51 PLATES

130 LIST OF ILLUSTRATIONS

LENDERS TO THE EXHIBITION
· ·

Archives Historiques et Musée de la Préfecture de Police, Paris

David Breskin

Stanley B. Burns, M.D., and the Burns Archive

California Historical Society Library, San Francisco

California Historical Society, San Francisco

California State Archives

Amon Carter Museum, Fort Worth

Corbis-Bettmann, L.L.C.

Federal Bureau of Investigation

Fine Arts Museums of San Francisco

Fondo Fotografico, Museo Cesare Lombroso

Fraenkel Gallery, San Francisco

Gilman Paper Company Collection

Howard Greenberg Collection

Howard Greenberg Gallery

Mark Haddawy Collection

Peabody Museum of Archaeology and Ethnology,
 Harvard University

International Center of Photography, New York

Robert Flynn Johnson

Kansas State Historical Society

Arlette and Gus Kayafas

Gérard Lévy, Paris

Prints and Photographs Division, Library of Congress

Harry H. Lunn, Jr.

The Metropolitan Museum of Art

Metropolitan Police Historical Museum, London

Andrew Moss

The Museum of Modern Art, New York

Museum of the City of New York

National Archives and Records Administration
 Pacific Region (San Francisco)

National Archives, Washington, D.C.

National Portrait Gallery, Smithsonian Institution

Nebraska State Historical Society

New York City Municipal Archives

New York Public Library

Peter E. Palmquist

Private Collections

Sebastian Rodriguez Archive

Paul Sack

San Francisco Museum of Modern Art

San Francisco Police Department

Shapiro Gallery, San Francisco

Albert H. Small

Patterson Smith, Antiquarian Bookseller

Glenn Spellman Fine Art Photography, New York

Underwood Photo Archives, Inc.

United States Holocaust Museum

The Library, University College London

The Bancroft Library, University of California, Berkeley

Archives and Special Collections, Library and Center for Knowledge
 Management, University of California, San Francisco

Special Collections, University of Nevada-Reno Library

Photography Collection, Harry Ransom Humanities
 Research Center, the University of Texas at Austin

The Board of Trustees, Victoria and Albert Museum

Thomas Walther Collection, New York

Sandra Weiner

Stephen White Associates

Stephen Wirtz Gallery, San Francisco

Yale Collection of Western Americana, Beinecke Rare
 Book and Manuscript Library, Yale University

FOREWORD AND ACKNOWLEDGMENTS

The invention of photography in the nineteenth century generated an almost immediate interest in its use for evidence gathering and scientific investigation. Early on, police detectives recognized photography's unique capacity as a forensic aide to record the "facts" of a crime scene and to document suspects and abet their capture. By the 1880s police photography had become systematized in France, while in the United States police departments were amassing extensive "rogues' galleries" and "wanted" posters routinely included mug shots of criminal suspects.

As Curator Sandra Phillips illuminates in the opening essay of this volume, this development was concomitant with a heightened interest in understanding the pathology of crime and criminals, as well as with a desire to discern the connections between outward physical appearances and inner character traits. Spurred on by the ideas of Charles Darwin and other social philosophers, physicians and scientists quickly incorporated the nascent photographic medium into their studies in order to illustrate how physiognomy and phrenology could be interpreted to reveal and categorize elements of race, class, gender, and ethnicity. Photography, as a "scientific" invention, was seen as neutral and carried with it the authority of "truth."

Police Pictures: The Photograph as Evidence explores how these nineteenth-century notions have influenced and continue to inform how photographic images are used for investigation, evidence gathering, and scientific categorization. This exhibition and accompanying catalogue reveal that many of these "evidence" photographs offer not an absolute truth but an ambiguous one. These images are not objective statements of fact. Rather, they are subjective documents of personal perception—both on the part of the photographer and the viewer—and are necessarily imbued with the social and cultural circumstances in which they were made.

This exhibition has been masterfully assembled by Sandra S. Phillips, curator of photography at the San Francisco Museum of Modern Art, and we thank her for her dedicated work on this important project. Dr. Phillips's most recent contribution to the study of the documentary tradition in photography examines works that were made not with an explicit aesthetic purpose, but which, nonetheless, embody expressive properties unique to the photographic medium. *Police Pictures* is not simply an examination of a specific genre—the evidence picture—but actually a much broader inquiry into the ambiguity, conceptual aspects, and rhetorical force of photography itself.

The San Francisco Museum of Modern Art is very pleased to be sharing *Police Pictures* with the Grey Art Gallery and Study Center at New York University, and we thank Lynn Gumpert, director, for her interest in joining with us in this endeavor.

An exhibition of this dimension and complexity could not have been achieved without the generous assistance of numerous sponsors and professionals in the field. The exhibition and publication received an early and important grant from the National Endowment for the Arts, a Federal agency. Additional support for the project is generously provided by Frances and John Bowes; Mrs. Walter A. Haas, Jr.; and Pat and Bill Wilson.

On behalf of Dr. Phillips, I would like to extend thanks to Dr. Douglas R. Nickel, associate curator of photography at SFMOMA; Dr. Susan Fillin-Yeh; Thomas Kelly; Eugenia Parry; Patterson Smith; and Dr. Larry Sullivan for reading early drafts of her manuscript and offering insightful comments. Thanks are also due to Julie Lindon and Kim Timby for their aid in the extensive research undertaken to help make possible Dr. Phillips's essay and the exhibition itself. For additional help with research, we thank Christine Karallus, Jeannette Redensek, Luc Sante, Allan Sekula, and Kerry Tremain, as well as

Genya Markon for her assistance in translating Polish.

Many SFMOMA staff members assisted in the planning and presentation of *Police Pictures*. In particular, I would like to acknowledge the role of Dr. John R. Lane, former director, whose leadership of the Museum for the past decade provided an environment in which projects such as this one—characterized by scholarly depth, timeliness, and innovation—were frequently brought to fruition. Special appreciation is also due to the following: Dore Bowen, intern; Lorna Campbell, assistant registrar; Olga Charyshyn, associate registrar; Alina del Pino, museum technician; Suzanne Feld, curatorial assistant; Tina Garfinkel, head registrar; Barbara Levine, exhibitions manager; Bonnie Levinson, deputy director, external affairs; Jill Sterrett, conservator; Kent Roberts, installation manager; Ariadne Rosas, secretary for the Department of Photography; Thom Sempere, graphic study manager; Marcelene Trujillo, exhibitions assistant; and Greg Wilson, museum technician.

For their thoughtful catalogue essays that serve as admirable complements to Sandra Phillips's, we thank Carol Squiers, senior editor at *American Photo*, whose text focuses on crime photography in tabloids of the 1930s; and Mark Haworth-Booth, curator of photographs at the Victoria and Albert Museum, London, who writes about the use of photography in nineteenth- and twentieth-century detective fiction.

Museum staff members Kara Kirk, publications manager; Alexandra Chappell, publications assistant; Catherine Mills, director of graphic design and publications; Terril Neely, senior designer; and Snowden Becker, administrative assistant in the director's office, as well as designer Michael Sumner and editors Melody Sumner Carnahan and Genoa Shepley all contributed their expertise to this publication, and we thank them for their assistance. Once again, it has been a pleasure to work with Chronicle Books, our copublisher on this project. In particular, Annie Barrows, former senior editor; Karen Silver, former associate editor; and Pamela Geismar, designer, were enthusiastic and supportive partners throughout this process.

We are deeply obliged to the lenders to this exhibition, listed on page six of this catalogue, and we would especially like to acknowledge the following individuals for facilitating the loan of these photographs and materials: Brenda Applegate, registrar, California State Archives; Miles Barth, curator of archives and collections, International Center of Photography, New York; Robin L. Chandler, head, Archives and Special Collections, Library and Center for Knowledge Management, University of California, San Francisco; Leslie Clemens, writer, Research/Communications Unit, FBI; Genevieve Fisher, registrar, Peabody Museum of Archaeology and Ethnology, Harvard University; Gillian Furlong, archivist, the Library, University College London; Maryl Hosking, loan administrator, New York Public Library; Beverly Joel, curatorial assistant, Department of Prints and Photographs, Museum of the City of New York; Gus Kayafas, Palm Press, Inc.; Gérard Lévy, Galerie Gérard Lévy, Paris; George Miles, curator, Yale Collection of Western Americana, Beinecke Rare Book and Manuscript Library, Yale University; Gene O'Donnell, supervisor, Investigative and Prosecutive Graphic Design Unit, FBI; William M. Roberts, acting curator, Pictorial Collections, the Bancroft Library, University of California, Berkeley; Antonella Russo; Janet Skidmore, assistant curator, Department of Prints, Drawings, and Paintings, Victoria and Albert Museum; Emily Wolff, photograph collection manager, California Historical Society.

Many of the photographs presented in this exhibition are graphic in their depiction of violence and death, yet some are hauntingly beautiful. All of them, from nineteenth-century daguerreotypes to present-day surveillance stills, reveal the complexity and ambiguity inherent in photographs purporting to "document the facts."

LORI FOGARTY
Deputy Director for Curatorial Affairs

. .

FACING PAGE:
Weegee (Arthur Fellig)
Murder in Hell's Kitchen
ca. 1940
Collection of the International Center of Photography, New York.
Bequest of Wilma Wilcox

POLICE
PICTURES

· · · · · · · · · · · · · · · · · ·

The Photograph as Evidence

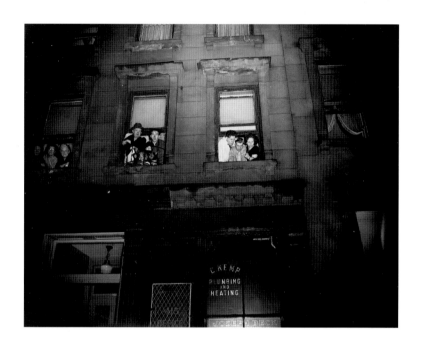

IDENTIFYING THE CRIMINAL

.

Sandra S. Phillips

We need criminals because they are not us. Crimes are transgressive acts, committed not by "normal" people but by those we define as outside the norm. It would appear that the systematic reaffirmation of this distinction is fundamental to our society. Our ability to distinguish right from wrong enables us, as responsible citizens, to identify, prosecute, and punish outlaws —individuals who flaunt social values. Paradoxically, the status of criminals as outsiders has made them heroes in our culture: the guilt, the "otherness," ensures freedom from society's strictures in a way that simultaneously attracts and frightens us.

In the past, before the penal reforms of the late eighteenth century, criminals were treated with more open viciousness than they are now: they were physically branded, hanged, stoned, or quartered in grisly public spectacles. It was easy to identify a criminal because, it was believed, he or she looked like one. Even as the nineteenth century progressed and scientists came to realize the psychological complexity of human behavior, most people continued to believe that

criminality could be distinguished by physical traits. Still today, when we see a criminal's face, we scan it attentively for indications, for some hidden insight into the crime. Appearances, it seems, do matter.

When O. J. Simpson—a famous, wealthy, attractive, black man—was apprehended in Los Angeles in 1994 for the murder of his beautiful (and white) wife, one major magazine put his mug shot on the cover, and another modified the same picture to produce a darker image, one more in keeping with cultural stereotypes of what a criminal looks like.[1] The comparison speaks directly to the powerful imaginative hold photography continues to have over us, even as it brings to public consciousness the insidious problem of using photographs for "documentary" purposes.

In America, the tolerance of crime is greater than in most other Western countries, and camera-based images have both glorified violence and functioned as a tool to contain it. No other country in the developed West endures the degree of gratuitous bloodletting shown hourly on television sets in most American homes. No other state permits its citizens to carry lethal weapons, either in the open or concealed. The American tradition of individual "rights" has historically accepted, even applauded, what would be considered antisocial behavior in other places. Nonetheless, our curious beliefs about personal conduct and criminal behavior arose from distinctly European traditions of thought, in particular, those from the emergent nineteenth-century social sciences—anthropology, ethnography, psychology, and sociology—which, with a new confidence in objectivity, "reason," and factual verification, in effect bolstered many of the customary ways of thinking about the criminal.

However, facts are not neutral: in their generation and selection they shoulder the burden of cultural

. .
Fig. 1 [page 10]
Eugène Atget
Versailles, maison close, Petite Place. Mars 1921
(Versailles, Brothel, Petite Place. March 1921)
1921
Photography Collection; Miriam and Ira D. Wallach Division of Art, Prints, and Photographs; The New York Public Library; Astor, Lenox, and Tilden Foundations

meaning, and this is revealed nowhere more forcefully than in nineteenth-century discussions of criminality. Thomas Henry Huxley, the champion of Darwin's evolutionary theory, typifies the Victorian faith in particulars: "Sit down before the facts as a little child," he counseled. "Be prepared to give up every preconceived notion, follow humbly wherever and to whatever abyss nature leads, or you shall learn nothing."[2] The figure of scientist-as-child, who possesses absolute, unprejudiced, even biblical innocence, is a characteristic nineteenth-century conceit, and as science gradually, but incontrovertibly, replaced religious faith as the new doctrine, hard, and presumably "objective," observation came to supplant metaphysical speculation.[3] Photography, a nineteenth-century technological invention, was seen to embody the new authority of empiricism. Photographs, used as evidence of fact, readily partook of and circulated within this larger scientific atmosphere, where the new study of criminology was emerging as a parallel cultural phenomenon. Many of the important scientific projects of the era exploited the photograph's perceived impartiality—as well as its speed, accuracy, and fidelity—to record or constitute their findings. Such forensic use continues to the present day.

From a contemporary perspective, many nineteenth-century photographs of crimes and criminals belie their intended purposes—namely, to prove the existence of innate, visible traits in deviants, or to serve as a dispassionate document of their deeds. Composite photographs of "criminal types," made during the period by combining several exposures of specific felons, lose all specificity and impart a fabricated ideal, which may even at times appear angelic (pl. 7). Early evidence pictures of scenes of murder often convey a sense of great and inexplicable beauty approaching the sacred. Perhaps because death is the obverse of life, beautiful pictures of death possess a strange, transformative power, becoming a sort of substantiation, an affirmation of the power and mystery of irrationality and brutality. Since we no longer have gladiatorial contests or public tortures, we now seek a peculiar kind of sublimity through the mediation of photography: we experience violence, witness death or its aftermath,

FIG. 2

Panorama of Man, frontispiece of the book *Heads and Faces and How to Study Them: A Manual of Phrenology and Physiognomy for the People* (1885), by Nelson Sizer and H. S. Drayton

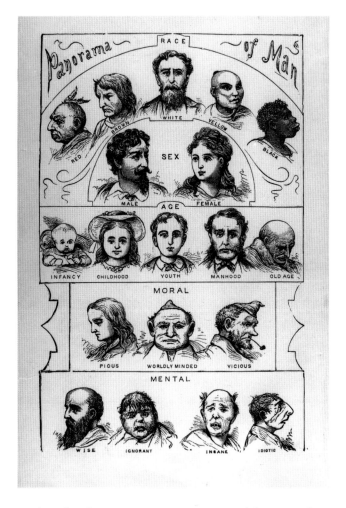

know the criminal and the details of violent crime in a way that is profoundly mysterious and ultimately reassuring. The crime photo gives us imaginative access to savagery; the mug shot becomes a mirror of what we fear may reside within us. Between chaos and reason lies the photograph.

DARWIN, RACE, HEREDITY, AND THE CRIMINAL IN THE NINETEENTH CENTURY

Photography's cultural advent in the 1840s and 1850s took place against a background of unprecedented upheaval in Western moral and scientific thought. Probably the single most significant scientific event of the nineteenth century was the publication in 1859 of Charles Darwin's book, *The Origin of Species.* Darwin's genius was to link two basic concepts: that the changes that occur in biological beings are passed down from generation to generation, and that an organism inheriting characteristics that increase its ability to adapt has the best chance of survival. These ideas were profoundly disturbing to Darwin's contemporaries for they carried with them the implication that man was not made in the image of God as described in Genesis, but rather, was the product of the same accidental, competitive, violent forces that governed other animals. Darwin understood the implications of his theory of natural selection long before *Origin* was published, exclaiming, for example, in an 1838 notebook, "the Devil under form of Baboon is our grandfather!"[4] Like his contemporaries, he felt more comfortable with the notion that human progress was something moral— and ultimately correctable. The ramifications of this belief in correctability for a colonial power like Great Britain were certain: according to Rudyard Kipling, the "white man's burden" was to take care of, and presumably elevate "the new caught, sullen peoples/half devil and half child" and make good subjects out of them.[5] Moral progress and random mutation were distinctly at odds, at least where it came to justifying the Commonwealth as part of God's divine plan.

Darwin's work had enormous implications for both science and the emergent social sciences. Yet, even before 1859, the tenets of what was later to be called "Social Darwinism" were being posited by Herbert Spencer, the English philosopher responsible for the phrase "survival of the fittest." Racial and cultural distinctions preoccupied Victorian social philosophers at the height of the British Empire, so they devoted themselves to defining

"savagery"—and to distancing themselves from it. They assumed that the undesirable characteristics they discovered in "savages" were inborn and tended to equate the savage "state" with a lack of social and moral development. These Victorians (who were men, usually aristocrats, and proudly Eurocentric) perceived qualities of impulsiveness and improvidence as characteristics of the savage; these traits, which were seen as indications of moral inferiority, also were shared by women, children, the poor, the laboring classes, the Irish, and the criminal.[6] Identity was thus defined through opposition: the Victorian assured himself of his place in the world by pointing to all the things he was not.

Mid-century philosophers and natural scientists took up the Darwinian program by eagerly studying both the inherent properties of human beings, as well as their distinguishing external traits, in order to systematize and classify them. In what one textbook author called the *Panorama of Man* (fig. 2), this is done through comparison to animals: this depiction attempts to represent the whole spectrum of racial, gender, age, moral, and mental differences, including not only the "pious" and "wise" types but also the "vicious" and "idiotic." The "lower" orders look menacing and savage, rather like animals. When the social observer Henry Mayhew began his study of the laborers and poor of London, he prepared himself by reading the ethnologist J. C. Prichard, who had conveniently divided mankind into two types, the "wanderers"

and the "settlers." Mayhew was led to believe that street wanderers (i.e., the poor) were not only culturally but *physically* different from the settled peoples (the middle and upper classes)—he believed, in fact, that their very heads were shaped differently.[7]

In the nineteenth century, the perceived threats to the upper and middle classes came essentially from the lower classes, those who inhabited the cities in the great wave of industrialization. Because they were poor, lacked education, and often fell victim to disease, it was convenient to think of these people as belonging not only to a different class, but to a different race. Social thinkers found evidence for this in what they saw as a propensity for a low state of morality, and a concomitant propensity for crime. Such philosophers believed that the ease with which the poor might enter into crime was revealed in their appearance. Thus, when a criminal was visualized by popular moralizers—including Charles Dickens and Gustave Doré—he looked like a brute, like a less evolved being. The terms "high brow" and "low brow" originally conflated physical, moral, and social states (figs. 3, 4).

Thus, under the banner of scientific theory, the idea of the innate nature of the criminal was formulated, but it was an idea by no means original to the nineteenth century. Johann Kaspar Lavater, the Swiss priest and author of *Essays on Physiognomy*, published in 1789, claimed to be able to judge a person by "reading" his or her features and facial

Fig. 45.

FIG. 3
Palmer, the English Poisoner,
from *The Illustrated Annuals of Phrenology and Physiognomy for the Years 1865-6-7-8 and 1869* (1869), by S. R. Wells

FIG. 4
Idiot, Malefactor, and Poet,
figure 3 of the book *Heads and Faces and How to Study Them: A Manual of Phrenology and Physiognomy for the People* (1885), by Nelson Sizer and H. S. Drayton

Fig. 3. Idiot, Malefactor, and Poet.

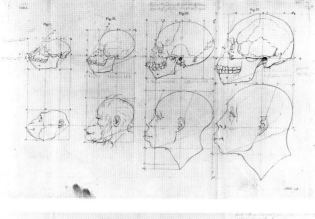

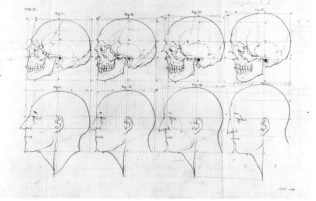

FIGS. 5 AND 6
Petrus Camper
Tables I and II, from *The Works of the Late Professor Camper on the Connexion between the Science of Anatomy...*(1821)
1935
Special Collections, The Library and Center for Knowledge Management, University of California, San Francisco

expressions. He describes physiognomy as "the Science of discovering the relation between the exterior and the interior—between the visible surface and the invisible spirit which it covers. . . ."[8] He proposed that his science would not only be beneficial to artists, to better express the varieties of human experience, but it could have practical application as well, including that of exposing vicious or criminal persons.[9] His assumption "of the Harmony between Moral Beauty and Physical Beauty" meant that every good person looked like one and was attractive, while a morally bad person must be ugly.[10]

In the early part of the nineteenth century, the concepts of physiognomy were applied to the new study of phrenology, which quickly became a popular—and unscientific—fad. Summing up the presumed connections between evolution, bestiality, and malfeasance, one of the practitioners of phrenology could write, "I have often been impressed in criminals, and especially in those of defective development, by the prominent ears, the shape of the cranium, the projecting cheek-bones, the large lower jaws, the deeply-placed eyes, the shifty,

animal-like gaze."[11] The fatalism of this brand of thinking, so disturbing to the twentieth-century reader, was typical of the time.

Theorists before Lavater focused on man's physical correspondences with animals as well. Giovanni Battista della Porta, the sixteenth-century Italian naturalist credited with being the first to describe and illustrate the camera obscura, had related certain personality characteristics of animals to the features of persons they resembled, and so had the great French academician Charles Le Brun, anticipating Lavater by more than one hundred years.[12] If a person looked like an ox, he also assumed some of that animal's character.[13] This theory lent itself easily to caricature[14] but the visual resemblance of people to animals also became the subject of serious scientific study. The Dutch anatomist Petrus Camper proposed a geometric progression of what he called the "facial angle." His first chart in this study compared the lowest primate forms (monkey, orangutan) to the black man and Asian (fig. 5); the next chart traced the contemporary European to the "ideal" (and presumed extinct) ancient Greek type (fig. 6).[15] Camper wanted to describe a large natural phenomenon, and was careful not to create a hierarchy of superiority. Later on, others were not so careful.[16]

Lavater's physiognomical science was of interest to Franz Joseph Gall, the Austrian doctor who had formulated phrenology in the early nineteenth century. Gall's thesis was based on the observation that the brain is the centralized nervous system in man,

FIG. 7

Title page of *The Illustrated Annuals of Phrenology and Physiognomy for the Years 1865-6-7-8 and 1869* (1869), by S. R. Wells

This image is a later representation of Franz Joseph Gall's ideas.

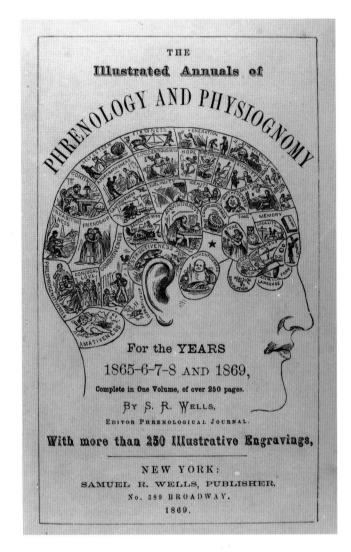

and that its functions were compartmentalized into different areas—he named twenty-three distinct functions and claimed to have located them all (fig. 7). Reasoning that the skull grew around the shape of the brain, he thought he could read a person's inner character by the exterior formations of the skull bone. He used the principles of physiognomy and portraits of famous persons to explain relationships between the external appearance and the internal personality or character.[17]

Physiognomy and phrenology were also of interest to those involved in the incipient study of the insane, which was evolving from early notions of "lunacy" to a more scientific, medical orientation. The physician Hugh Welch Diamond, for example, was interested in accurate physical representations of the insane as a key to understanding their condition and as an aid in developing a cure. He proposed that the facial expressions of the insane were a diagnostic clue to the kind of madness they suffered.[18]

The study of facial expression also interested Darwin. His last major book, *The Expression of the Emotions in Man and Animals*, published in 1872, was illustrated with photographs meant to portray internal characteristics through facial expressions. Some of these images were posed by the photographer Oscar Gustave Rejlander; others were unposed, or "pure" expressions: pictures of babies crying and pouting, and those of the insane. Darwin also included photographs of patients receiving electric shock as administered by the French doctor Guillaume-Benjamin Duchenne (known as Duchenne de Boulogne), who had wished to prove by these curious pictures the thesis that expression is not individual but a universal abstraction of emotion, unencumbered by personality (pls. 12, 13). For this reason Duchenne seems to have chosen a "simple" man on whom to concentrate his experiments. Duchenne claimed to study the "orthography of facial expression"—its principles—and compared his experiments on living people with ancient masterworks of idealized expression, such as the Hellenistic sculpture the *Laocoön*.[19] Darwin used these photographs to support his own study of the biological purpose of expressions and their original and precultural meanings in man and animals.

The belief in the revelatory quality of facial characteristics was nowhere more pernicious than in the

daguerreotypes of slaves collected in 1850 by the naturalist and Harvard professor Louis Agassiz.[20] Agassiz was an ambitious and charismatic Swiss, a friend of the great Baron von Humboldt and a student of Baron Cuvier, both eminent naturalists. A singular personality, Agassiz energized the study of natural history in the United States during his tenure at Harvard. He saw himself as a corrective force to the speculative German *Naturphilosophie*, because he relied on strict study of actual, physical evidence, a result of his work with Cuvier. Aside from his great influence on the study of geology in this country, Agassiz also turned his attention to the biology of man. Agassiz was a "special creationist": that is, he believed that the dissimilarities in mankind's races were the result of different moments of creation—as opposed to a single moment of creation—and that, therefore, all humans were not related as a species. In the years immediately before the Civil War, these ideas were powerfully appealing to Southerners, who saw Agassiz as a champion of the basic inequality of races, and thus as an apologist for the institution of slavery.

Agassiz's reactions to black people were not impassive. In 1846, on his first visit to the United States, he wrote home of the impressions he had of seeing his first black man, a domestic servant:

I hardly dare to tell you the painful impression I received, so much are the feelings they gave me contrary to all our ideas of the brotherhood of man and unique origin of our species. But truth before all. The more pity I felt at the sight of this degraded and degenerate race, the more . . . impossible it became for me to repress the feeling that they are not of the same blood as we are.[21]

Agassiz's fascination, even obsession, with racial evaluation led him to study black slaves when he visited Charleston, South Carolina, the following year. He decided to concentrate his investigations on recent arrivals from Africa and their immediate offspring because he thought they were purer representatives of their race. Soon after he returned to Boston, he received a series of daguerreotypes made by J. T. Zealy of Columbia, South Carolina. These pictures of native-born and first-generation enslaved Africans were made in strict profile, front, and back views, resembling mug shots. The subjects' clothes were removed for more precise anthropological examination. Ironically, the force of personality of the subjects is so compelling, the individuals almost transform the indignities to which they, as scientific specimens, were exposed (pls. 2–5).

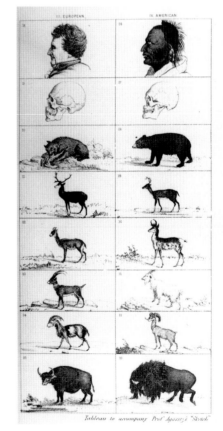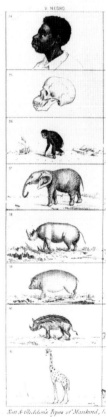

. .
FIG. 8
Tableau to Accompany Prof. Agassiz's "Sketch," from the book *Types of Mankind: or, Ethnological Researches, Based upon the Ancient Monuments, Paintings, Sculptures, and Crania of Races, and upon Their Natural, Geographical, Philological, and Biblical History* (1854), by J. C. Nott and George R. Gliddon

Agassiz apparently felt the need to supplement the slave pictures with daguerreotypes of various other ethnic groups, and thus it appears that he added to the collection representations of Native Americans and Chinese persons, similarly considered lesser "species" than white European man.

Agassiz also agreed to participate in a study of racial difference that, even by the standards of his time, was considered flawed. When he first visited America, he had seen the skull collection of Samuel Morton, a Quaker who studied cranial size and shape and believed that brain size was an indication of intelligence. Agassiz also struck up a friendship with Morton's student, the Southerner J. C. Nott, during his visit to the South. When Nott joined George Gliddon to produce the ponderous study *Types of Mankind . . .*, Agassiz agreed to contribute an essay.[22] The charts featured in this book not only describe the specific vertebrate forms that relate to the eight racial types Agassiz had identified, but also characterize their personalities (fig. 8). Though Agassiz did not take the next step and assign character types to the different races, his colleagues did not have the same compunctions. Thus, the study reads, for example, "A small trace of white blood in the Negro improves him in intelligence and morality."[23]

Also during the nineteenth century there developed another side to the debate about the roots of deviant behavior, and it focused on the environmental influences toward criminality. In 1840, Eugène Buret, a French social philosopher, also compared poor European classes to savages, but with an important difference: they were made so by their social and economic conditions. He wrote:

> *The destitute [in France] resemble the bands of Anglo-Saxons who took to a nomadic life in the forests to escape the Norman yoke. They are outside society, outside the law, outlaws; and almost all criminals come from their ranks. Once distress has brought its weight to bear on a man, it gradually presses him down, degrades his character, strips him of all the benefits of civilized life one after another and imposes upon him the vices of the slave and the barbarian.*[24]

Although the French found comfort in the fact that nineteenth-century London was more dangerous and inhabited by more impoverished persons than Paris, the city's criminal culture was the subject of Victor Hugo's massive novel *Les Misérables* (1862), and was also of great interest to Honoré de Balzac. Social upheaval was painfully familiar as well: the French suffered revolutions and restorations during a period of relative social stability in England, and Paris was the site of the bloody Commune of 1870–71. It is not surprising, therefore, that in France, scholars and writers gave serious consideration to the relationship of social conditions to what they referred to as the "dangerous classes," those persons on the low end of the social scale, the end from which criminals came. Hugo's hero, the "outlaw" Jean Valjean, for instance, commits the crime of stealing a loaf of bread to feed his famished sister and her family. Hugo's treatment of this subject reveals his attitude toward what he and some other nineteenth-century French commentators saw as the actual "crime": the circumstances in which people like the fictional Valjean were forced to live. They viewed crime as a form of social illness, not an innate characteristic of criminals, but rather a social pathology, the consequence of a sick and dangerous society.[25]

EARLY APPLICATIONS OF PHOTOGRAPHY IN CRIMINAL STUDY

The first instance of photography applied specifically to the understanding of crime occurred when Mathew Brady, a recent arrival to New York City, accepted a commission to photograph prisoners in Blackwell's Island prison in 1846.[26] Eliza Farnham, the young matron who sponsored Brady, was a follower of the phrenological reformist Marmaduke Sampson (a follower of George Combe), and like them she believed that a correct reading of criminal features would correlate with a person's true inner character, and that such a person might be curable with appropriate treatment. All of the illustrations in Sampson's book, *The Rationale of Crime* (1846), after Brady's daguerreotypes of prisoners, feature brutish or deranged looking people. Farnham was a determined antagonist to the death penalty and an

advocate of a more enlightened attitude toward prisoners during the nineteenth-century wave of reform; nevertheless, she shared with her contemporaries certain racial and ethnic biases toward criminals. Ironically, Mrs. Farnham suffered attacks on her character and political ideas as the result of her reforming intentions.[27]

As early as 1854, the San Francisco Police Department made daguerreotype portraits of criminals, and other departments throughout the country followed suit, although in an unsystematic way. Local police departments fashioned "rogues' galleries," which usually comprised cartes-de-visite (small pictures attached to calling-card-sized boards) placed on racks or assembled into albums with specific information about each criminal inscribed on the back (pls. 38, 40). However, the most impressive and extensive early crime pictures in the United States were a series made by Alexander Gardner around President Lincoln's assassination in 1865. Gardner idealized Lincoln and ardently supported the Northern cause in the Civil War. First as the director of Mathew Brady's photography studio in Washington, D.C., and later as proprietor of his own studio there, Gardner had access to the president and had made admiring, even tender, portraits of him. He also produced a book of Civil War views that was adamantly partisan.[28]

When the assassination occurred, the Secret Service hired Gardner to perform photographic duties, and he did not fail to recognize the potential market value of pictures related to the event. He copied portraits to include in the wanted poster for the conspirators (pl. 21) and documented the area around the assassination shortly after it occurred. He was the only one permitted aboard the iron-clad monitors, the U.S.S. *Saugus* and *Montauk*, where the prisoners were held, and later he was the only photographer to witness their execution (pls. 22–25).[29]

One of the conspirators was Lewis Powell (alias Lewis Paine or Payne), who attempted to murder William S. Steward, secretary of state, at the same time that Lincoln met his death. To Gardner, Powell must have appeared an archetypal conspirator of biblical proportion. His powerful body and open defiance were in sharp contrast to the appearance of the other prisoners, stolid and unimaginative looking, more like the typical members of a rogues' gallery.

Gardner also photographed relics from the confederate Andersonville prison (pl. 26), as well as the sensational execution of Henry Wirtz, the prison commandant accused of grossly mistreating Union soldiers held there. Since there were no reproductive processes available for photography until later in the century, Gardner's pictures (like other contemporary photographs) were widely copied through wood engravings and published in the pages of *Harper's* magazine.

THE FRENCH CONTRIBUTION

In France, the introduction of photography for the purposes of apprehending criminals occurred partly by accident, not long after Lincoln's death. In 1871, soon after the defeat of France in the Franco-Prussian War, a civil war erupted in Paris between the newly elected (and German backed) National Assembly and a group of revolutionary insurgents resisting what they saw as the repressive policies of the new government. Although the Paris Commune lasted only three short months, it was one of the bloodiest and most violent episodes the city had seen. The Communards established their own municipal council to wrest control away from the Assembly in order to create a more egalitarian republic.

Proud of their accomplishments, the Communards photographed some of the events that occurred during the few months of their government's existence. They razed (and photographed) the Vendôme Column as a symbolic act. This monument to Napoléon Bonaparte represented to them the militarism, conservatism, and imperialism that had ignited the war with Prussia. To their great misfortune, however, when French government troops reentered the city, they used the triumphal group pictures and small carte-de-visite portraits to track down former Communards and kill them. Photographs of the destroyed city and montages of the Commune's bloodier moments also were used as effective propaganda to suppress any sympathy for the Communards and their cause.[30]

After the Commune, the French police took a more serious interest in a young and rather strange police department clerk named Alphonse Bertillon. The son of a statistical anthropometrist, Bertillon had been experimenting with a rational system of measurement to identify criminals for a number of years (pl. 14). In 1872, the year after the Commune, when he finally proved his unique method could capture recidivists, the police department began to use Bertillon's system: a series of measurements he considered specific to each body and descriptions of characteristic markings, coupled with two photographs. These pictures became what we now know as standard mug shots: two neutral, standardized views of the face of the accused—one taken frontally and one in profile. Bertillon called these photographs *portraits parlés* ("speaking likenesses") and he classified and filed them according to their measurements. The major drawbacks of this system were the size of the archive, which soon grew precipitously, and the need for completely accurate measurements recorded according to a scrupulous set of standards. As the number of prisoners increased, these measurements and photographs became harder to retrieve and track.

Cumbersome though it was, Bertillon's methodology was particularly helpful in the apprehension of habitual criminals, as exhibited in 1884 when Bertillon used it to identify the anarchist known as Ravachol after he threw a bomb into a building where a government bureaucrat lived.[31] Although the French police had been familiar with Bertillon's methods for a while, they were motivated to employ it more systematically to control the new heresy of social radicalism.

Bertillon's work became widely known and valued in the United States when his method was publicized at the World's Columbian Exposition in Chicago in 1893. The following year the Chicago police adopted his system, and in 1898 Chicago established the National Bureau of Criminal Identification based on Bertillon's methods. His system was challenged in 1903, however, when a man named Will West was arrested and sent to the prison at Fort Leavenworth, Kansas. Although he claimed he had not been arrested before, his photograph appeared to match that of a convicted criminal, and so, apparently, did his Bertillon measurements. As it turned out, there was another man named William West already incarcerated in the same prison who had approximately the same measurements and who looked very similar to the newer prisoner. The only conclusive evidence distinguishing the two men was found to be in their fingerprints. From this time onward, fingerprinting was done as a matter of course and used in conjunction with photographs. Gradually the Bertillon anthropometric system was abandoned.[32]

The use of photographs in apprehending criminals, however, continued. Mug-shot books came into regular use by the late 1880s, and examination of them reveals the extreme diversity of the criminal population in America at the time. Prisoners in San Quentin came from Europe, China, and Mexico, as well as from many regions of the United States (pl. 39). Of all races and many ages, these criminals represented the opposite of the "American Dream": they were usually poor and often immigrants. Alarmingly, young children appear in these books; often they have been arrested for "vagrancy," and one supposes they were homeless (pl. 32). By the 1880s, "wanted" posters commonly included identifying pictures (pl. 41). Mug-shot books were also kept by private police, such as the Pinkerton Agency, who used them as surveillance guides on trains, where the population at large traveled. Other volumes were compiled presumably as records of aliens, such as the itinerant Chinese population, and were probably also used for purposes of surveillance (pl. 16).

Meanwhile Bertillon expanded his work in the study of criminals by pioneering the use of scientific analysis to solve crime. He taught classes for the French police on identification techniques, and he produced charts of the variations in eye, ear, nose, mouth, hairline, and skull formations (pl. 15). He was also responsible for formalizing evidence pictures of crime scenes.[33] His system included mats with scales on the sides of the picture, which helped calculate a floor plan of the crime scene. He also invented the *photographie stéréométrique*, a picture of the front and side view of the same object, usually a corpse. The

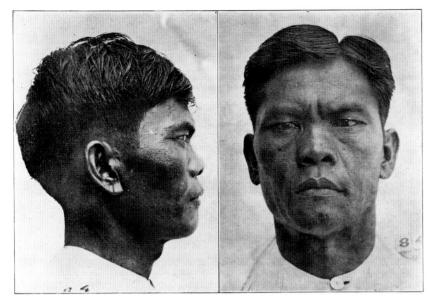

FIG. 9
Daniel Folkmar
A Bicol of Ambos Camarines Province,
from *Album of Philippine Types Found
in Bilibid Prison in 1903*
1904

front views were made with a wide-angle lens and a tripod looking directly down on the object. As one writer noticed, the body is seen from the perspective of God, presumably the ultimate objective view (pl. 48).[34]

THE IMPLICATIONS OF BERTILLON'S WORK

The influence of Bertillon's methodology was widespread and influential, in part because it evolved in tandem with the anthropological study of racial typology. For example, his system was much publicized at the St. Louis Exposition of 1904, where a study representing the varieties of races in Southeast Asia was exhibited. This study employed Bertillon's mug shots and anthropometric measurements, but the Philippino subjects of these pictures were also actual prisoners (fig. 9). Although prisoners had been the objects of scientific inquiry for Gall, who had based his ideas on his own study of criminals, such ostensibly objective projects often contained an unacknowledged (or unconscious) racial or class bias.

Even more obvious to contemporary sensibilities are the colonial pictures depicting the "barbarity" of Asian people—especially the exotic customs of beheadings or physical torture. In India, where the colonial English were harassed by local challenges to their power, such pictures had propaganda value. For the American public, Native Americans were

subject to specious racial attributions. Since the time of the Puritans, the Indian had often been depicted as a frightening savage, a physically powerful, vengeful, and irrational figure. However, Indians were tolerated, even admired as "noble" savages when they were on the verge of extermination toward the end of the nineteenth century, and as such were photographed, notably by Edward Curtis. Some pictures escaped these cultural stereotypes, but were certainly still influenced by cultural ideas.

In 1874 war broke out between the American government and the Modoc tribe who lived in a rugged, desolate area near Mt. Shasta in Northern California. The Modoc War was the costliest Indian battle to the U.S. government, both in terms of financial expenditure and the number of soldiers killed. The Modoc Indians had been forced out of their native lands, had experienced the bad faith of white treaty makers, and had suffered constant encroachment by "American" settlers. They were driven to fight when some of the younger Modocs seceded from their tribe in a display of independence, if not desperation. After brave but mostly symbolic defiance, the Modocs surrendered, and four of them were hanged.

The German immigrant photographer Louis H. Heller made small, card-mounted photographs of the renegade Modoc leaders and their captors, which Carleton Watkins sold in his San Francisco

gallery (pl. 17). These pictures reveal the Indians to be complex figures and are in no way sensationalistic. Rather, these sad, ambiguous photographs must have been made for their newsworthiness and documentary value more than for any racial stereotyping of the outlaw "wild" Indian. Captain Jack, their leader, wears the modest clothing of a farmer, his hair is short, and his most distinguishing characteristic is an expression of profound melancholy.[35]

In later pictures made by other photographers at the site of the Wounded Knee massacre in South Dakota, the old surviving Indians seem to be reminders—even relics—of a lost fierceness more than worthy adversaries (pl. 18). In the bloodbath of that massacre, even the white men (and especially the photographer) must have sensed the weary tragedy of the outcome.

The Development of Criminal Anthropology

The search for a criminal type, as opposed to a specific "rogue" or felon, continued to occupy philosophers and scientists. Sir Francis Galton, a cousin of Charles Darwin, expressed his fear about the demise of the upper classes and of the "highly evolved" white race in his first major book, *Hereditary Genius*, published in 1869.[36] He held the belief that the ancient Athenians were the human ideal (albeit an extinct one), and considered the aristocratic English to be closest to them, although he feared they were in danger of losing their elevated position. However, Galton's contemporaries, including Darwin, were skeptical about applying ideas from *The Origin of Species* to human eugenics, as Galton proposed.

Galton also thought that composite photography could be a useful tool for visualizing types such as the tubercular, the prize-winning racehorse, and the criminal (pl. 7). He was fastidious enough to classify portraits by the type of crime committed by their subjects: according to him, violent offenders looked different from nonviolent ones. Yet Galton's pictures are neither threatening nor frightening. Since they are abstractions, they now appear uncannily beautiful. He admitted as much himself:

It will be observed that the features of the composites are much better looking than those of the components.

The special villainous irregularities in the latter have disappeared, and the common humanity that underlies them has prevailed. They represent, not the criminal, but the man who is liable to fall into crime.[37]

Galton's theories on eugenics persisted, however, and in photography reemerged with a vengeance under the Nazi regime in the 1930s. This is reflected in anthropological photographs from that era, which depict the German ideal racial types and their antithesis: Jews and other "criminals"—including gypsies, homosexuals, socialists, and felons—who were imprisoned in Auschwitz.

Galton's ideas on the inborn properties of race and the racial anthropology of the criminal were further developed into the study of criminal anthropology by an Italian, Cesare Lombroso. In his treatise on the subject, originally published as *L'Uomo delinquente* in 1876, and later as *Criminal Man*, Lombroso considered the criminal an example of biological atavism, a throwback to an earlier stage in man's evolution—although he later was forced to recognize that some criminals were not of this subhuman type.[38] Although Lombroso's importance has waned, he was the first to seriously address the biological aspect of crime, calling attention to certain causes of crime not subject to the Enlightenment ideal of free will.[39] He claimed that most criminals were mentally deformed (he determined that they had an abnormal skull formation similar to that found in rodents) and that epileptics were often criminals. Lombroso referred to what he saw as innate criminal traits as "stigmata," which explained,

. . . the problem of the nature of the criminal—an atavistic being who reproduces in his person the ferocious instincts of primitive humanity and the inferior animals. Thus were explained anatomically the enormous jaws, high cheek-bones, prominent superciliary arches, solitary lines in the palms, extreme size of the orbits, handle-shaped or sessile ears found in criminals, savages, and apes, insensibility to pain, extremely acute sight, tattooing, excessive idleness, love of orgies, and the irresistible craving for evil for its own sake, the desire not

only to extinguish life in the victim, but to mutilate the corpse, tear its flesh, and drink its blood.[40]

Lombroso was also convinced that tattoos were a sign of deviance and savagery, and documented both pornographic and anarchistic tattoos as significant indications of "criminal" behavior.[41]

The Criminal as a Subject for Art

While practical police officers had little use for Lombroso's theory, his ideas were important to other of his contemporaries, particularly intellectuals, who romanticized the outsider as belonging to a special and fascinating class or race. Havelock Ellis, the English social scientist known mainly for his study of sexual behavior, was most interested in Lombroso's idea of a differentiated criminal being, one with its own culture and customs.[42] Later, this notion also had an influence on interwar figures such as Pierre Mac Orlan, whose novels and film scripts conveyed a romantic view of criminals, and it also influenced the photographers Brassaï and Bill Brandt. Mac Orlan illustrated his personal copy of Lombroso's 1896 book *La Femme criminelle et la prostituée* (The Criminal Woman and the Prostitute)[43] by pasting in photographs by Eugène Atget (from a series on prostitutes commissioned by another artist and connoisseur of the lowlife, André Dignimont), along with anonymous, mainly pornographic pictures (fig. 1; pls. 57, 58).

Mac Orlan, like his Surrealist colleagues, thought of Atget as a naive artist. These intellectuals, who knew the photographer, felt they had discovered a genuine "primitive" master. Mac Orlan also wrote enthusiastically, even lyrically, about anonymous— and sometimes graphic—photographs. Like Atget's work, such pictures provoked "the absolutely free evocation of subconscious thought," wrote Mac Orlan. He illustrated this observation with an anonymous police picture of a bloody bed, the scene of a violent murder.[44]

Younger members of the Surrealist group, such as Georges Bataille, demonstrated an even greater delectation of pictures of ambiguous, implied violence. Bataille, and to a lesser extent the anthropologist and art historian Michel Leiris, admired

expressions of the erotic power of death. They also looked at prehistoric, anonymous, and "primitive" art as redemptive—as a legitimate form more intense and evocative than the work of self-conscious artists. To them, both the anonymous found object, as well as subjects of death and violence seemed to be purer and more genuine sources for aesthetic expression.[45]

Shortly after Mac Orlan expressed enthusiasm for the bloody police picture, the social philosopher Walter Benjamin also made an association between the "naive" Atget and the aesthetic potential of crime scene photographs: "Not for nothing were pictures of Atget compared with those of the scene of a crime. But is not every spot of our cities the scene of a crime?"[46] And later, in another essay, he writes:

It has quite justly been said of him [Atget] *that he photographed* [deserted streets around 1900] *like scenes of crime. The scene of a crime, too, is deserted; it is photographed for the purpose of establishing evidence. With Atget photographs become standard evidence for historical occurrences, and acquire a hidden political significance . . . free-floating contemplation is not appropriate to them. They stir the viewer, he feels challenged by them in a new way. At the same time picture magazines begin to put up signposts for him; right ones or wrong ones, no matter. For the first time, captions become obligatory.*[47]

The aesthetic appreciation of evocative pictures, such as those by Atget, was too frightening and too challenging to be left unguided.[48] For Benjamin's less sophisticated contemporaries, these pictures needed to be placed into a scenario and, even, a moralistic explanation, a readily understandable context. Such morality plays occurred in the pages of the sensational police magazines of the time, lavishly illustrated by police pictures, many supplied by Bertillon himself.

The Outlaw: An American Romance

Americans had a singular kind of criminal specific to the West, depicted imaginatively during the nineteenth century in cheap, sensational serials (called the "Penny Dreadfuls") but also known to us

through rare, original photographs. After the Civil War, many former Confederate soldiers moved westward, sensing they would have a better future there than in the routed, depressed South. Jesse James was one of the most memorable men to exploit the social malaise of the post–Civil War era (pl. 27). Cheap novels (and the song, "The Ballad of Jesse James," popularized after his death) depicted him as noble and manly, possessing his own sense of honor, a kind of Robin Hood involuntarily made an outcast. According to legend, he stole money accumulated by Eastern capital interests—the banks and railroads—to aid the struggling, harassed poor. Historical evidence offers a less romantic portrait of James, but he was, nonetheless, a highly charismatic figure to his contemporaries.[49]

Oklahoma became a useful refuge for outlaws because it was originally Indian territory—outside local government jurisdiction. In addition to colorful outlaws, the West had other elements that contributed to its "wild" reputation. In the relatively remote Western mining towns across the West, gun battles and other forms of irregular justice took place. Alive or dead, outlaws were highly prized subjects for photographers, and probably very lucrative ones, as well. The directness of these pictures, and in some, the almost iconic treatment of violent death, suggest the importance the subjects played in representing the "untamed" West (pl. 28).

Later, the Depression reactivated Western outlaw and vigilante activity. In 1933, a mob in San Jose, California, broke into the local jail house, forcibly removed two men arrested for the kidnapping of Brooke Hart, the son of the local department store owner, and beat and lynched the two men (pl. 61). Unlike such occurrences in the South, which also took place during the hard Depression years, the California lynching was not a racially motivated act. Governor James M. Rolph, who explicitly allied himself with the old vigilante tradition of the Gold Rush days, which he had witnessed as a young man, did nothing to stop the lynching. He staunchly defended the principle of citizens taking the law into their own hands.[50]

While Americans tolerated, even mythologized, the violent outlaw in the country's heartland, vio-

lence in the cities was perceived as the activity of dangerous foreigners. Americans feared the "flood" or "rising tide" of immigrants, most of whom were coming to the cities, particularly New York. Many of the "huddled masses" who entered the United States around the turn of the century were from Eastern and Southern Europe, and were considered by social theorists to be lower on the evolutionary scale and thus more prone to criminality.[51] One early philanthropist, observing the treatment of children in New York City, was disarmingly explicit:

> *The brutal American is of the rarest. It is because New York is less an American city than almost any other in the United States that the need for the Society for the Prevention of Cruelty to Children was so sore. As the foreign element increased, and every form of ignorance with it, drunkenness as well as natural brutality worked together.*[52]

By the early twentieth century criminal literature was a flourishing industry, and the public's interest in crime increased with the invention of cinema. By the 1930s the dangerous foreign "mobster"—a city dweller—along with the western outlaw, became instantaneous film celebrities. Some of the most fascinating records of the era, however, are the albums and scrapbooks of policemen, assembled as personal memorabilia of the events they witnessed. A massive collection of these albums was kept by a San Francisco policeman, Jesse Cook, who later became chief of police and then served as a member of the police commission. Cook's collection included newspaper clippings (mainly about himself or on the history of the police in the city), his own snapshots, photographs appropriated from other sources, and official police photographs, mixed in with odd personal mementos.

Cook's scrapbooks record changing and conflicting views of criminals from the early decades of the century to near the midpoint. They reflect the concerns of an American western metropolis, a port town, a city distinguished by a large, complex, foreign population, much of which was desperately poor. These books comprise a history of conventional attitudes toward the romanticized outlaw "other"

as well as toward the ordinary criminal type. They contain, among many others, pictures of transvestites, the sleeping inhabitants of an opium den in Chinatown, a kidnapping site, and the presumed anarchist bombing at a pro-war Preparedness Day parade on Market Street (pls. 59, 60, 62).

CRIME IN THE CITIES

In New York City an old-fashioned, tough-guy police inspector named Thomas Byrnes publicized his version of the nature and appearance of the criminal in his colorful piece of self-promotion, *Professional Criminals of America*, published in 1886. It is illustrated with pictures of criminals from the rogues' galleries, with captions noting their "professions" (pl. 36). Contrary to popular ideas, Byrnes claimed, criminals did not necessarily look like what they really were.

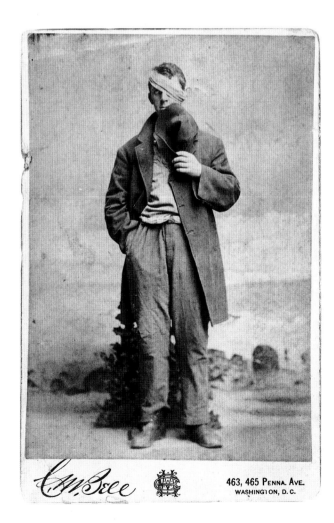

A burglar! This prim, genteel, thoughtful looking personage? He would be a minister or merchant or physician on the first flash to nine men out of ten. Here in the flare of the gaslight, in the heart of fashion, with a judge at his back and a millionaire at his elbow—a burglar? Not low browed, sullen, with stealthy glance and hunted air—not at all as fancy and romance have pictured him.[55]

Byrnes believed that publicizing the faces of criminals would inhibit them from committing crimes, but he also recognized that some criminals appreciated the notoriety such publicity gave them. Inspector Byrnes's opinions seemed simplistic and old-fashioned next to the more recent environmental understanding of crime.

Jacob Riis, a newspaper reporter for the *New York Tribune* and, later, the *Sun*, substantially changed the perception of the poor as shiftless, ignorant, and undeserving. Unlike Byrnes, he focused not on individual will but rather on the social circumstances that fostered criminal activity (pls. 33–35). To illustrate his points he first found photographer friends, sought professional assistance, and sometimes even resorted to taking pictures himself. Riis used photographs to illustrate special conditions: he conducted numerous public lectures, which were usually accompanied by

FIG. 10
C. M. Bell
George Harries (Washington, D.C., newspaper reporter disguised to be arrested in order to get story of bad conditions in Washington, D.C., jail)
1889
Collection of the San Francisco Museum of Modern Art

dramatic lantern-slide showings, and his abundant illustrated writings were undertaken in the service of his understanding of social justice.

Riis became interested in using photographs when, working as a newspaper reporter covering the poor immigrant sections of Manhattan at night, he found that words alone were not powerful enough to evoke the conditions he saw. He read about the discovery of magnesium flash powder that could be used by photographers to better light their subjects. Riis immediately seized on this as a vital aid to reveal the unseen to his readership: his subjects were usually asleep, drunk, or too preoccupied or frightened to object to a photographer, all of which gave the pictures authenticity and aided his "battle with the slums." The pictures could be invasive, however: on occasion he was fiercely chased by irate subjects, and more than once he accidentally set fire to a tenement with his incautious use of magnesium flash powder.

Byrnes's professed reason for publishing his book was to inhibit criminal activity, but he also appeared to be the hero in this drama of underworld characters—he was assertive, bold, and smart. Byrnes's book idealized the heroic police, a phenomenon also found in the treatment of Allan Pinkerton in contemporary police novels. Riis, on the other hand, wanted to reveal the conditions that fostered crime. When he published pictures of juvenile criminals who grew up on the streets, it was in order to demonstrate what happened when the community was blind to environmental conditions. Riis was concerned that such blindness was both morally and socially destructive. However, there is also an unacknowledged voyeurism in Riis's work, as well as in the social investigations of his contemporaries. Good intentions, a sense of moral superiority, and the alluring view into the degenerate, unseen truth impelled the book *Darkness and Daylight, or Lights and Shadows of New York Life,* written by Byrnes with two others, both philanthropists: Mrs. Helen Campbell and Colonel Thomas W. Knox.[54] This book, and others like it, reveal an ambiguous cultural fascination with the "underworld." One contemporary newspaper reporter even disguised himself as a criminal to personally investigate the prison system in Washington, D.C. (fig. 10).

Riis was a strong voice on the side of environmental causes of crime; on the other side were Lombroso's followers.[55] While biology appeared to suggest a hereditary element in crime, the new sciences of sociology, psychology, and soon criminology—signaled by the establishment of the American Institute of Criminal Law and Criminology in 1909—indicated both the complexity of the cases of crime and the increasing professionalism applied to the criminal problem. In 1915 William Healy published *The Individual Delinquent,* and its psychological orientation inaugurated the modern approach to criminal behavior, an attempt to understand the motives for committing crime.[56]

THE LEGACY OF J. EDGAR HOOVER

J. Edgar Hoover played a critically important role in modern criminal history. As director of the Federal Bureau of Investigation from its inception in 1924 until his death in 1972, Hoover was the single most powerful figure in law enforcement. He was a political reactionary at the same time that he held progressive views toward the use of science as an impartial tool in crime documentation and analysis.

Hoover's initial prominence came as a result of his fight with foreign radicals. The notorious "Palmer Raids" were launched during World War I by Attorney General A. Mitchell Palmer, who reflected the public anxiety about immigrants when he stated that "fully ninety percent of the communist and anarchist agitation is traceable to aliens."[57] Hoover championed Palmer's beliefs, which he couched in nineteenth-century-style descriptions of the criminal type:

> *Most of the individuals involved in this movement are aliens or foreign-born citizens. There are some, however, of unquestioned American extraction. Some of the leaders are idealists with distorted minds, many even insane; many are professional agitators who are plainly self-seekers and a large number are potential or actual criminals whose baseness of character leads them to espouse the unrestrained and gross theories and tactics of these organizations.... Out of the sly*

and crafty eyes of many of them leap cupidity, cruelty, insanity and crime; from their lopsided faces, sloping brows, and misshapen features may be recognized the unmistakable criminal type.[58]

Although Hoover's powers were eventually curbed in reaction to public outcry against the excesses of the Justice Department, his great autonomy and influence in the 1930s were made possible by Franklin Delano Roosevelt, who felt the need to restore confidence in a nation that had been immobilized and demoralized by the Depression. Although the rate of crime actually fell during the thirties, the many kidnappings and killings, the colorful crime bosses and outlaws that flourished in those years—in the "heartland" as well as in the cities—produced both popular, romantic admiration for criminals and a sense of public vulnerability.

Hoover not only wanted to eradicate crime, but what he considered the pernicious illusion of romance associated with it. He became an activist crime buster, adopted the slogan "truth, justice, and the American way," and at the time was represented in films and frequently appeared in the news. "Pretty Boy" Floyd, John Dillinger, "Machine Gun" Kelly, and "Baby Face" Nelson transformed crime into political melodrama, with G-men acting as the defenders of American liberty, ably and bravely directed by Hoover (pls. 69–71).

There is no romance in crime and there is no romance in criminals. . . . They are the absolute opposite. They are rats, vermin, regurgitating their filth to despoil the clean picture of American manhood and womanhood. They sink deeper and deeper into a morass of viciousness which inevitably leads to filth in mind, filth in living, filth in morals and in bodily health. They travel steadily downward until at last they are no more than craven beasts.[59]

In addition, Hoover's deep fear of political radicalism was fueled by Roosevelt's request that he investigate "subversion," defined as "matters relating to espionage, sabotage, and violations of the neutrality regulations."[60] This accelerated after the president proclaimed a state of emergency on September 9, 1939, and the country edged into war, fueled by the advance of German fascism. Directed by Roosevelt, Hoover focused attention on the rise of fascism and, later, on the Cold War enemies of the United States.

Hoover considered Roosevelt's successor, Harry S. Truman, insufficiently serious about communist threats, which led him to try to manipulate other branches of government. As a result, increasingly after Roosevelt's death, Congress vigorously persecuted members of the left. Thus, a new outlaw appeared in the FBI files: the political "bad man." Hoover considered the informer Joseph Fuchs, captured by the FBI, a more dangerous figure than Julius Rosenberg (but not enough to commute Rosenberg's death sentence, which he vigorously pursued). Hoover's fixation on the evilness of the political left persisted until the end of his life and blinded him to the need to address other criminal activity, such as the rise of the Mafia. His deep antipathy to civil rights prevented him from prosecuting offenders of racially motivated crimes. Hoover's attitudes also explain the FBI campaigns of subversion against radical groups that challenged both the Vietnam War and the social inequities of the period (pl. 86).

A striking example of Hoover's professional methods and attitudes in crime photography is the documentation of presidential candidate Robert Kennedy's assassination. Hoover had great difficulty with Robert Kennedy, who, as attorney general, had directed him to investigate organized crime and challenged his old-fashioned value system by a belief in the social and economic causes of crime. The evidence file contains masses of photographs of everything from accused assassin Sirhan Sirhan's socks hanging rather pathetically on a wire hanger to the countless photographic reenactments of the bullet's trajectory (pl. 83). Hoover's methodology—collecting every piece of factual material—was exhaustive, scientifically detached, and morally neutral, and perhaps, in this case, also reflected a sense of hopelessness; the relentless collection of facts reveals the vanity and futility of ever truly comprehending the illogic of violence.

CRIME PHOTOGRAPHY TODAY

Since Hoover's death, the FBI has sought to maintain the standards he set for it by employing the highest level of scientific methodology for solving crime. The content of crime photographs has not changed, only the technology.

Surveillance is not only more accurate and scientific but more common. Not limited to government use, cameras are now found in malls, in banks, in middle-class apartment buildings, and on street corners, photographing traffic-light violators. The United States–Mexico border is monitored by infrared video (pl. 87). Evidence pictures are still made, but in different kinds of light or employing new technologies to capture subtle, minute, and often unseen clues: a shoe print; the imprint of a person's body wrapped in a bag; the impression of a written message, later crossed out, on a pad with doodles; or traces of DNA or fibers, identified by chemical or microscopic analysis.

As in the nineteenth century, the perception of the omnivorousness and omnipotence of science is as unsettling as it is reassuring. An example of the disturbing ramifications of minute scientific analysis is the deconstruction of the videotape evidence of motorist Rodney King's beating by Los Angeles police officers in 1991. Slowing down the speed, analyzing the action frame by frame, disconnecting the whole renders the "objective proof" of this film meaningless.

Science is still used to explain criminal or deviant behavior. Lombroso's specific ideas have been discredited, but now certain patterns in chromosomes are thought to identify a predilection for asocial behavior. Scientific theory has proven to be susceptible to very human, cultural biases; and scientists, willfully or not, have misread data while presenting it as "objective truth." Knowing this, how can we use technology to solve crime and suppress criminality and remain free of bias? Since photography plays such a central role in solving crime, how can we assure ourselves that photographs are purely factual and neutral?

We look at photographs in different ways than did nineteenth-century photographers. We understand the psychological content, the social context,

.
FIG. 11
Andy Warhol
Most Wanted Men, No. 1, John Mo
1964
Collection of the Herbert F. Johnson Museum
of Art, Cornell University. Purchase Funds
from the National Endowment for the Arts
and individual donors.

the strange aesthetic value of the pictures, and sometimes even the humor. But photographs as objects do not really give us specific information, except the most obvious: what a certain subject looked like under particular circumstances at a certain time. Any other information needs to be coaxed out of them—or read into them. Although the photograph can be a tool, an instrument of visual recording, the ways in which the tool is used implies a host of assumptions and philosophies.

During the past three decades, criminals and other "transgressives" have figured rather prominently in works of art as witnessed by Andy Warhol's 1964 series *Most Wanted Men,* which depicts archetypes of the contemporary outlaw (fig. 11), and in Larry Clark's photographic book *Tulsa,* which documents a gang of drug-using outcasts.[61] Now, the criminal, outcast, and outsider are in vogue again in art and media culture. This comes at a moment when the country seems obsessed with punishing the criminal, a tendency that has a distinctly racial and class element. Because our society has successfully heroicized the transgressor, photographs of criminals and criminality seem more relevant for reexamination and contextuality.

The issue of identity in contemporary society, and the role photography plays in identifying the criminal, is a large and ambiguous one. In the 1960s, when France was trying to control the Algerian drive for independence, Marc Garanger, a young journalist serving his obligatory military duty, was ordered to make identity cards for women living in rural areas of Algeria. These women, who were forbidden by custom and law to expose their faces to anyone outside their family, had to submit to this official invasion of their bodies. Furthermore, in Cambodia, the ruling Khmer Rouge photographed persons as they entered the notorious Tuol Sleng Prison, before they were tortured and executed (pls. 92–94). Many innocent people were among those who died and, one wonders, why were these pictures made? Was there some distorted belief in the photograph's ability to act as an impartial witness? Identity photographs, which our contemporary society finds necessary for its proper functioning, might easily turn into tools of surveillance and repression, as they did during the Third Reich in Germany and, more recently, in South Africa.

Since photography is so deeply engaged with identity, how can we in this "information age" protect the outsider while protecting ourselves from the criminal? This is a necessary question when we remember the history of demonizing the outsider, the radically different person, the members of the lower classes, or the immigrants in our own society. Even the driver's license, which seems as innocuous as it is necessary, could be put to wrong or abusive use. Can we assure ourselves that we are not making identity photographs for the purposes of exclusion, for defining who criminals are, so that we can keep them on the outskirts of our society?

NOTES

This work is indebted to the pioneering essay by Allan Sekula, "The Body and the Archive," *October* 39 (Winter 1986), 3–64; as well as to Michel Foucault's *Discipline and Punish: The Birth of the Prison,* trans. Alan Sheridan (New York: Vintage Books, 1995). See also *In Visible Light: Photography and Classification in Art, Science and the Everyday,* eds. Chrissie Iles and Russell Roberts (Oxford: The Museum of Modern Art, 1997); and see *The Division of Labor in Society,* trans. George Simpson (1933; reprint, Glencoe, Ill.: The Free Press, 1947), chap. 2, in which Emile Durkheim, writing in the 1930s, a time of political, social, and artistic turmoil, describes the criminal as the person who offends the collective social beliefs of a society, a society that needs him in order to ritually reassert the authority of these beliefs.

1. See cover of the June 27, 1994, issue of *Newsweek* for original mug shot; see cover of the June 27, 1994, issue of *Time* for the altered mug shot; see also "To Our Readers," *Time,* July 4, 1994.

2. In a letter from Thomas Henry Huxley to Charles Kingsly, September 23, 1860; reprinted in Leonard Huxley, *Life and Letters of Thomas Henry Huxley,* vol. 1 (ca. 1900; reprint, New York: AMS Press, 1979),

218ff. See also the discussion of empiricism in Peter Gay, *The Bourgeois Experience*, vol. 3 of *The Cultivation of Hatred* (New York: W.W. Norton & Co., 1993), 447ff, where Huxley is quoted.

3. Auguste Comte proposed his "law" stating "each of our leading conceptions—each branch of our knowledge—passes successively through three different theoretical conditions: the Theological, or fictitious; the Metaphysical, or abstract; and the Scientific, or positive." In *The Positive Philosophy of Auguste Comte*, vol. 1, trans. Harriet Martineau (London: George Bell and Sons, 1896), 2–3.

4. Charles Darwin's "Baboon" grandfather is quoted in his "M Notebook," in *Metaphysics, Materialism, and the Evolution of Mind: The Early Writings of Charles Darwin*, ed. Paul H. Barrett (Chicago: University of Chicago Press, 1980), 29. See George W. Stocking, Jr., *Victorian Anthropology* (New York: The Free Press, 1987), 142–43, about the Victorians of the mid-1850s before Darwin, and 223–38, about hereditary racial characteristics.

5. Rudyard Kipling, "White Man's Burden," *Collected Verse of Rudyard Kipling* (New York: Doubleday, 1907), 215–17.

6. See Stocking, 19–33.

7. See Henry Mayhew, *London Labour and the London Poor: A Cyclopaedia of the Condition and Earnings of Those that Will Work, Those that Cannot Work and Those that Will Not Work*, vols. 1, 4 (London: Griffin, Bohn, and Company, 1861), 1: 1–2, 43; 4: xii.

8. Johann Kaspar Lavater, *Essays on Physiognomy: Designed to Promote the Knowledge and Love of Mankind*, vol. 1, trans. Henry Hunter (London: John Murray, 1789), 16–17.

9. Ibid., 77–78.

10. Ibid., 128ff.

11. Grohmann, Franz Joseph Gall's predecessor, quoted by Havelock Ellis in *The Criminal* (London: Walter Scott, Ltd., 1890), 29.

12. Giovanni Battista della Porta proposed a relationship of the interior personality to the external features of man in his *De humana physiognomia* (Naples, 1586). See also Patrizia Magli, "The Face and the Soul," in *Fragments for a History of the Human Body*, vol. 2, eds. Michel Fehrer, Ramona Naddaff, and Nadia Tazi (New York: Zone, 1989), 87–127.

13. See Lavater, 108, in which he writes about a person who resembles an ox: "Gross brutality, rudeness, force, stupidity, inflexible obstinacy, with a total want of tenderness and sensibility."

14. Many of the principles of Lavater, Charles Le Brun, and Petrus Camper were freely adapted by such caricaturists as Grandville. See Judith Wechsler, *A Human Comedy: Physiognomy and Caricature in Nineteenth-Century Paris* (Chicago: University of Chicago Press, 1982), especially the illustration on page 98.

15. See *The Works of the Late Professor Camper, on the Connexion between the Science of Anatomy and the Arts of Drawing, Painting, Statuary . . .*, ed. T. Cogan (London: J. Hearne, 1821).

16. See Barbara Maria Stafford, *Body Criticism: Imaging the Unseen in Enlightenment Art and Medicine* (Cambridge, Mass.: The MIT Press, 1993), 113ff, on how Camper's geometrical studies of human proportion were given racial meaning.

17. "Gall's physiological psychology, by uniting the mind with neurology on the one hand and the biology of adaptation on the other, seemed a conceptual triumph of the highest order, for it transformed abstract metaphysical conceptions of mind into actual organic entities amenable to the interests and understandings of the practical-minded." Roger Cooter, *The Cultural Meaning of Popular Science* (Cambridge: Cambridge University Press, 1984), 32.

18. See Adrienne Burrows and Iwan Schumacher, *Portraits of the Insane: The Case of Dr. Diamond* (London: Quartet Books, 1990), 35–41. Sir Francis Galton would also study mental patients (pl. 9).

19. For more on Duchenne de Boulogne, see Nancy Ann Roth, "The Photographs of Duchenne de Boulogne," in *Multiple Views: Logan Grant Essays on Photography, 1983–89*, ed. Daniel P. Younger (Albuquerque: University of New Mexico Press, 1991), 105–37; and see G.-B. Duchenne de Boulogne, *The Mechanism of Human Facial Expression*, ed. and trans. R. Andrew Cuthbertson (1876; trans. reprint, New York: Cambridge University Press, 1990). Duchenne believed that the personality of a man could be seen in his face and, "If a good man can be born with a wicked face, this monstrosity would sooner or later be effaced by the incessant influence of a good soul" (31).

20. These were discovered by Eleanor Reichlin. See her "Faces of Slavery," *American Heritage*, vol. 28 (June 1977), 4–5; and the more recent essay by Brian Wallis, "Black Bodies, White Science: Louis Agassiz' Slave Daguerreotypes," in *American Art* 9, no. 2 (Summer 1995), 39–59.

21. Agassiz quoted in Edward Lurie, *Louis Agassiz: A Life in Science* (Chicago: The University of Chicago Press, 1960), 257.

22. Josiah Clark Nott and George R. Gliddon, *Types of Mankind: or Ethnological Researches Based upon the Ancient Monuments, Paintings, Sculptures, and Crania of Races and upon Their Natural, Geographical, Philological, and Biblical History* (Philadelphia: Lippincott, Grambo, and Co., 1854).

23. Ibid., 68.

24. Eugène Buret quoted in Louis Chevalier, *Labouring Classes and Dangerous Classes in Paris During the First Half of the Nineteenth Century*, trans. Frank Jellinek (London: Routledge and Kegan Paul, 1973), 144.

25. See Chevalier, 10, on the "pathological nature of urban living." One of the most important persons to discuss the relationship of crime to social condition was the Belgian statistical genius Alphonse Quetelet. By amassing large quantities of statistics and shaping them into what he claimed were universal truths, or laws, he derived the notion of the "normal" or "average" man. It was Quetelet who first described man in relation to a bell-shaped statistical curve. See also Sekula's discussion of Quetelet in "The Body and the Archive," 20ff.

26. See Madeleine B. Stern, "Mathew Brady and the Rationale of Crime: A Discovery in Daguerreotypes," in *The Quarterly Journal of the Library of Congress* 31, no. 3 (July 1974), 127–35; and Alan Trachtenberg, *Reading American Photographs, Images as History: Mathew Brady to Walker Evans* (New York: Hill and Wang, 1989), 21–70. Trachtenberg also makes the point that the daguerreotype in Nathaniel Hawthorne's *The House of Seven Gables* (1851) reveals Judge Pyncheon to be the evil man he truly is but manages to hide in normal human intercourse (27–28).

27. Stern, 17. According to Stern, Mrs. Farnham was accused of being an "infidel" and "Fourierite."

28. Gardner wrote the following caption to describe the fallen Confederate soldiers in one photograph of Gettysburg: "Killed in the frantic efforts to break the steady lines of an army of patriots, whose heroism only excelled theirs in motive, they paid with life the price of their treason, and when the wicked strife was finished, found nameless graves, far from home and kindred." See Alexander Gardner, *Photographic Sketch Book of the Civil War* (1866; reprint, New York: Dover Publications, Inc., 1959), opposite pl. 36.

29. Pictures surrounding the death of John Wilkes Booth (he died when he was trapped in a burning barn) were deliberately limited by the government in an effort to prevent him from becoming a martyr. See D. Mark Katz, *Witness to an Era: The Life and Photographs of Alexander Gardner* (New York: Viking, 1991), 171; and Lloyd Ostendorf's essay, "Abraham Lincoln and the Conspiracy Against Him," in Brooks Johnson, *An Enduring Interest: The Photographs of Alexander Gardner* (Norfolk, Va.: The Chrysler Museum, 1992). Timothy O'Sullivan probably assisted Gardner.

30. Jeannene M. Przyblyski, "Preliminaries to a Treatment of Photography in the Paris Commune, 1871" (unpublished manuscript, 1994).

31. See Donald E. English, *Political Uses of Photography in the Third French Republic, 1871–1914*, Studies in Photography, vol. 3 (Ann Arbor, Mich.: U.M.I. Research Press, 1984), 79.

32. The Will West/William West dilemma is described in Harris Hawthorne Wilder and Bert Wentworth, *Personal Identification* (Boston: Richard G. Badger, 1918), 30–32. Bertillon had used fingerprints to convict Henri-Leon Scheffer of murder in 1902, and later used them to identify the culprits in the "Affaire de Thiais" (pl. 1). See Henry T. F. Rhodes, *Alphonse Bertillon: Father of Scientific Detection* (New York: Abelard-Schuman, 1956), 110–16.

33. See Alphonse Bertillon's book, *La Photographie Judiciaire* (Paris: Gauthier Villars et Fils, 1890), 46. Pictures of crime scenes had been made earlier, such as the police photographs of the Clerkenwell explosion in London (fig. 20)—the work of Fenian activists—but not systematically, as Bertillon proposed.

34. See the essay by Eugenia Parry Janis, "They Say I and I: and Mean: Anybody," in *Harm's Way: Lust and Madness, Murder and Mayhem*, ed. Joel-Peter Witkin (Santa Fe: Twin Palms Press, 1994); and the earlier works by Luc Sante, *Evidence* (New York: Farrar, Straus and Giroux, 1992) and *Low Life: Lures and Snares of Old New York* (New York: Farrar, Straus and Giroux, 1991).

35. See Peter Palmquist, "Imagemakers of the Modoc War: Louis Heller and Eadweard Muybridge," *The Journal of California Anthropology* (Winter 1977), 206–41; and "Photographing the Modoc Indian War: Louis Heller and Eadweard Muybridge," *History of Photography* 2, no. 3 (July 1978), 187–205.

36. Sir Francis Galton, *Hereditary Genius: An Inquiry into Its Laws and Consequences* (1869; reprint, New York: St. Martin's Press, 1978).

37. Galton, "Composite Portraits," *Journal of the Anthropological Institute of Great Britain and Ireland*, vol. 8 (1879), 135.

38. Cesare Lombroso's *L'Uomo deliquente* was published in French and Italian, and expanded with illustrations, in 1895 and 1896. Lombroso's daughter adapted his theories and published them in English, including an introduction by her father: see Gina Lombroso Ferrero, *Criminal Man, According to the Classification of Cesare Lombroso* (New York: G. P. Putnam's Sons, 1911). He states in the introduction that America has an "almost fanatical adherence" to his ideas, xi.

39. For a contemporary analysis of Lombroso's theories on biological determinism, see Stephen Jay Gould, *The Mismeasure of Man* (New York: W. W. Norton and Co., 1993), 120ff.

40. Lombroso Ferrero, xv.

41. Ibid., 45–48. Others thought differently. As Dr. Larry Sullivan points out, Leo Berg (*Der Ubermensch in der Moderner Literatur*, 1897) claims that the best and strongest went to jail; and August Drahms (*The Criminal*, 1897), thought tattoos the sign of the wayfarer, not necessarily the criminal or outcast.

42. See Havelock Ellis, *The Criminal* (London: Walter Scott, Ltd., 1890).

43. According to Lombroso, most prostitutes, like other deviants, were born, not made.

44. See Pierre Mac Orlan, "La Photographie et la fantastique sociale," *Les Annales* (Nov. 1, 1928), pp. 413–14; and also his essay, "Photographie: elements de fantastique sociale," *Le Crapouillot* (Jan. 1929), 3. These ideas are clearly related to Surrealism.

45. See Michael Richardson, *Georges Bataille* (London: Routledge, 1994), 63; and Rosalind Krauss's essay, "Corpus Delicti," in *L'Amour Fou: Photography and Surrealism* (Washington, D.C.: Corcoran Gallery of Art, and New York: Abbeville Press, 1985), 57–100.

46. Walter Benjamin, "A Short History of Photography," *Artforum* 15, no. 6 (Feb. 1977), 51, trans. Phil Patton from "Kleine Gesischte der Photographie," *Literarische Welt* (Sept. 18, 25, Oct. 2, 1931).

47. Benjamin, from his essay "The Work of Art in the Age of Mechanical Reproduction," reproduced in *Illuminations*, trans. Harry Zohn (New York: Harcourt, Brace and World, 1969), 226.

48. H. Prinzhorn, a psychologist partial to German Expressionist art, also wrote a book on the expressive and aesthetic character of art produced by the insane: *Bildnerei der Geisteskranken* (Berlin: Springer Verlag, 1922). He later wrote about the aesthetics of criminals' art: *Die Bildnerei der Gefangenen* (Berlin: Axel Junker Verlag, 1926).

49. See Franck Richard Prassel, *The Great American Outlaw: A Legacy of Fact and Fiction* (Norman: The University of Oklahoma Press, 1993).

50. See Charles Morgan Evans, "Anatomy of a California Lynching" (unpublished M.A. thesis, San Francisco State University, 1992), 70.

51. Ysabel Rennie, *The Search for Criminal Man: A Conceptual History of the Dangerous Offender* (Lexington, Mass.: Lexington Books, 1978), 125.

52. Mrs. Helen Campbell, Col. Thomas W. Knox, and Sup't. Thomas Byrnes, *Darkness and Daylight, or Lights and Shadows of New York Life* (Hartford, Conn.: The Hartford Publishing Company, 1895), 170.

53. Thomas Byrnes, *Professional Criminals of America* (1886; reprint, New York: Chelsea House Publishers, 1969), 53.

54. See generally Campbell, Knox, and Byrnes. See also Theodore Roosevelt's observation on the confusion of poverty with criminality: "Pauperism is to blame for the unjust yoking of poverty with punishment, 'charities' with 'correction,' in our municipal ministering to the needs of the Nether Half," quoted in Jacob Riis, *How the Other Half Lives* (1901; reprint, New York: Dover, 1971), 201.

55. In the 1870s there were two books on the subject that were deeply influential in America: Charles Loring Brace's *The Dangerous Classes of New York and Twenty Years' Work among Them* (New York: Wynkoop & Hallenbeck, 1872); and R. L. Dugdale's *"The Jukes": A Study in Crime, Pauperism, Disease and Heredity* (1877; reprint, New York: Putnam, 1895).

56. See Larry K. Hartsfield, *The American Response to Professional Crime, 1870–1917*, in *Contributions in Criminology and Penology*, no. 8 (Westport, Conn.: Greenwood Press, 1985), chap. 5.

57. A. Mitchell Palmer quoted in Richard Gid Powers, *Secrecy and Power: The Life of J. Edgar Hoover* (New York: The Free Press, 1987), 70.

58. Ibid., 73.

59. Ibid., 210. J. Edgar Hoover quoted in an address to Hi-Y Clubs, June 22, 1936.

60. Ibid., 232.

61. Larry Clark, *Tulsa* (New York: Lustrum Press, 1971).

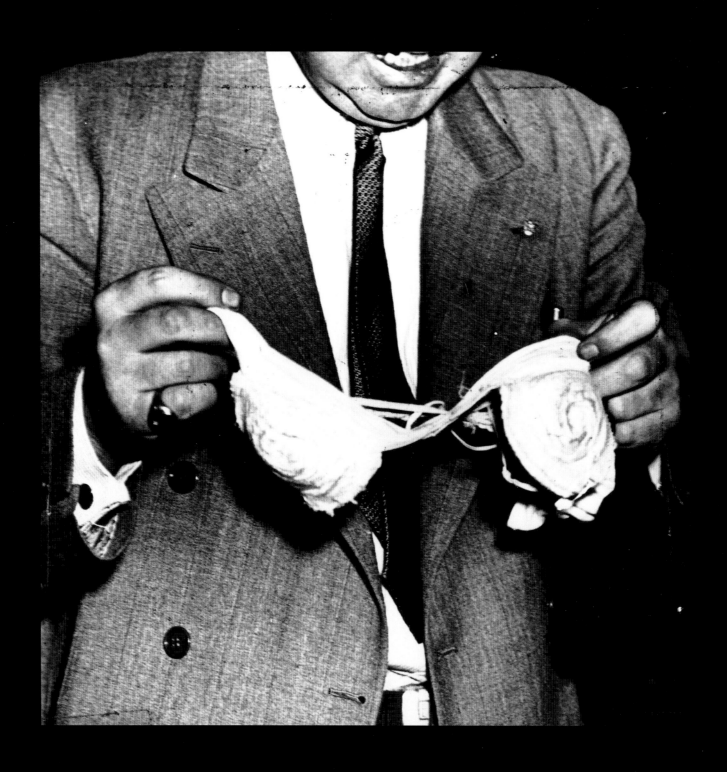

"A CAMERA EYE AS RARE AS A PINK ZEBRA"

Mark Haworth-Booth

Around 1840 two new personages appear within western society, twin figures noteworthy for the startling qualities of vision they share. Thanks to the independent inventions of Louis Daguerre and Henry Talbot, Paris and London simultaneously witnessed the birth of the photographer in 1839. Two years later, the detective first appeared as a character in fiction, in the writings of Edgar Allen Poe. Detectives and photography were both fashionable novelties of the 1840s and 1850s, so perhaps metaphorical connections between them were inevitable. Since that time, however, there has been a remarkable constancy in the perceived link between the vision of fictional detectives and actual photographers. This brief essay follows some representative sleuths and their camera-vision from those early decades down to the present—even, perhaps surprisingly, into the era of cyberculture.

My thinking about the links between photographers and detectives began in the early 1980s[1] and received special impetus from an essay by Carlo Ginzburg. His study "Morelli, Freud and Sherlock

Holmes: Clues and Scientific Method," traced connections between the methods of the art connoisseur Giovanni Morelli, the psychoanalyst Sigmund Freud, and the fictional detective Sherlock Holmes.[2] All three based their working method on the interpretation of small and generally overlooked details—clues—which, when properly observed, could solve mysteries. Morelli, for example, is famous for his close attention to details in paintings, such as earlobes and fingernails, "the characteristic trifles by which an artist gives himself away, as a criminal might be spotted by a fingerprint." Morelli keyed his system for identifying the authors of anonymous works upon the subtle, involuntary stylistic evidence every painter unfailingly leaves behind.

What Ginzburg terms the "conjectural paradigm"—speculative deduction from clues—has a long pre-history, dating back to the skills of the hunter and tracker, but the method came to fruition in the nineteenth century: "It coincided with the emergence of an increasingly clear tendency for state power to impose a close-meshed net of control on society...."[3] Such items as the *Bertillon System of Measurement and Identification* are highly characteristic of the Victorian era: Ginzburg's essay shows how fingerprinting, for instance, was adopted (from colonial Bengal) to become the universal method of criminal identification in the latter part of the nineteenth century. Though photography plays only a minor role in Ginzburg's argument, the strange and persistent resonances between detection and the camera deserve closer scrutiny. My purpose is to highlight the fascination of western societies with evidence, and particularly with the act of examining evidence, as exemplified in the activities of both detectives and photographers.

Detective fiction has become a staple of modern entertainment, transmitted to a mass audience through not only paperback books but also film and television, those grandchildren of the photographic

technologies first introduced in 1839. Now detective fact, as well as fiction, fills prime-time television slots. We are asked to ponder the significance of splashes of blood or a dropped glove, and are captivated by security-video images—images very like Dave Gatley's *Ghostly view through night vision infra-red scope...* (pl. 87). In Britain, a program called *Eye Spy* offers surveillance camera footage from around the world, airing at 8:30 p.m.—between a police serial and a murder mystery.

After Poe had invented the Parisian detective M. Dupin in 1841, it was twelve years before Charles Dickens introduced the first English detective, Inspector Bucket. In *Bleak House* (1853), Dickens makes a telling connection between photography and the power of observation employed by detectives in this character's description:

> He is a stoutly built, steady-looking, sharp-eyed man in black, of about the middle-age. Except that he looks at Mr. Snagsby as if he were going to take his portrait, there is nothing remarkable about him at first sight but his ghostly manner of appearing. (Chap. 22)

The phrase "going to take his portrait" is meaningful here. Everyone knows the uncomfortably frank examination—of the face as mere surface—involved in having a portrait taken. One can lose one's self-possession, in every sense. In the original manuscript for the story, Dickens wrote "as if he were going to take his portrait and had got it"—but scored out the last four words of the draft.[4] So Dickens originally thought of the notional portrait taken by Inspector Bucket as, significantly, *instantaneous*. Bucket—with his down-to-earth name—was based on a real policeman called Inspector Field, whom Dickens wrote about as "Inspector Wield" in several essays.[5] He was impressed by the policeman's ability to glance around a room and instantaneously take in all of its contents: Inspector Field had what we now call a "photographic memory." Walter Bagehot noticed a very similar quality in Dickens himself, remarking in 1858 that the writer "could go down a crowded street and tell you all that is in it, what each shop was, what the grocer's name was, how many scraps of orange peel

there were on the pavement . . . Mr Dickens's genius is especially suited to the delineation of London life. Everything is there and everything is disconnected."[6] His vision, like that of his hero/creation, Field/Bucket, was asocial, machine-like, non-hierarchical and completely inclusive. Another critic, writing in the *North British Review* in 1845, would condemn Dickens for this very quality: "Ludicrous minuteness in the trivial descriptive details induces us to compare Mr Dickens's style of delineation to a photographic landscape. There, everything within the field of view is copied with unfailing but mechanical fidelity."[7]

Dickens's friend and colleague Wilkie Collins was also fascinated by crime, evidence, and the way close observation could distill sense out of seemingly random phenomena. Perhaps he was talking about himself when he made the hero of *Basil* (1852) a fashionable young man who "went about with detective policemen, seeing life among pickpockets and housebreakers" (part 1, chap. 4). Basil takes an omnibus and amuses himself by scrutinizing the passengers:

An omnibus has always appeared to me to be a perambulatory exhibition-room of human nature. I know not any other sphere in which persons of all classes and all temperaments are so oddly collected together, and so immediately contrasted and confronted with each other. To watch merely the different methods of getting into the vehicle, and taking their seats, adopted by different people, is to study no incomplete commentary on the infinitesimal varieties of human character—as various even as the varieties of the human face. (Part 1, chap. 7)

Likewise, *Hide and Seek* (1854) displays an interest in the telltale detail. This sort of dialogue is familiar in later detective fiction: "'A dressmaker!' says I; 'how did you find out she was a dressmaker?' 'Why, I looked at her forefinger in [sic] course,' says Peggy, 'and saw the pricks of the needle on it, and soon made her talk a bit after that'" (chap. 4).

Collins developed characters with abnormal powers of observation, such as Matthew Gryce, amateur detective, who appears in the opening pages of the

book's second part: "His eyes were light, and rather large, and seemed to be always rather vigilantly on the watch. Indeed, the whole expression of his face, coarse and heavy as it was in form, was remarkable for its acuteness, for its cool, collected penetration, for its habitually observant, passively-watchful look." Interestingly, Gryce is an outsider, based on J. Fenimore Cooper's character Leatherstocking. Collins refers frequently to "those observant eyes of his which nothing could escape, and which had been trained by his old Indian experience to be always unscrupulously at work, watching something"(book 2, chap. 5). The *unscrupulousness* of this vision is important. The powers of observation of Collins's embryo detective—a.k.a. Mat, or Mr. Marksman—are explicitly contrasted with socialized and cultivated vision. Entering a room in which a painting of Columbus is displayed, Mat ignores the art but takes in the context:

The eye with which Mr. Marksman now regarded the picture was certainly the eye of a barbarian; but the eye with which he afterwards examined the supports by which it was suspended, was the eye of a sailor, and of a good practical carpenter to boot. He saw directly, that one of the two iron clamps to which the frame-lines were attached, had been carelessly driven into a part of the wall that was not strong enough to hold it against the downward stress of the heavy frame. (Part 2, chap. 5)

Collins uses the notion of "barbarian" vision here to suggest nothing less than an elevation of functional-realist seeing over a genteel vision that was blind to impending misfortune.

Photography was also regarded in many quarters at this time as a preternaturally observant, but inartistic outsider—brilliant at registering the details of phenomena but incapable of achieving the harmony of fine art. This view was set down most impressively by Lady Eastlake in the *Quarterly Review* in 1857.[8] "[Photography] is made for the present age," she writes, "in which the desire for art resides in a small minority, but the craving, or rather necessity for cheap, prompt, and correct facts resides in the public at large. Photography is the

purveyor of such knowledge to the world. She is the sworn witness of everything presented to her view." The review laments the medium's want of selection and rejection, its failure at effecting Art's mystical marriage of creative mind and object, but celebrates the technology's unique genius for engendering a "strength of identity" between the camera image and the world's concrete particulars. It is that evidential quality, that mechanical testimony and superhuman truth-to-fact, which activated a new cultural paradigm felt within and beyond the visual arts.

It is hardly surprising then that passages in Collins's novel *The Dead Secret* (1857) read like a photograph of a scene of a crime. They are surely informed by the author's familiarity with courtroom evidence and the minutiae of eyewitness descriptions. In the passage that follows, for example, Rosamond describes, for the benefit of her blind husband, the "Myrtle Room," which could contain a vital clue:

> Oh, yes! the ceiling—for that completes the shell of the room. I can't see much of it, it is so high. There are great cracks and stains from one end to the other, and the plaster has come away in patches in some places. The centre ornament seems to be made of alternate rows of small plaster cabbages and large plaster lozenges. Two bits of chain hang down from the middle, which, I suppose, once held a chandelier. The cornice is so dingy that I can hardly tell what pattern it represents. It is very broad and heavy, and it looks in some places as if it had once been coloured, and that is all I can say about it. (Book 5, chap. 5)

Collins extends his forensic style even further with *The Woman in White* (1860), written in the form of independent eye-witness narratives, in the manner of transcripts of criminal trials. In fact, the author found the plot in a book of French crimes he picked up from an old bookstall in Paris: Maurice Méjan's *Receuil des causes célèbres* (1808). The true-crime source and *verité* style combined to produce a novel destined for sensational popularity with Lady Eastlake's fact-craving public.

The idea of the clue or telling detail—exemplified in this century, for instance, by Weegee's *What was left in the paddy wagon after a raid on W. 30th Street* (fig. 12)—is itself highly photographic. It is also embedded in the earliest thinking about the medium. Talbot wrote in *The Pencil of Nature* (1844–46) about the pleasures of examining photographs with a magnifying glass and noting details—like a sundial on a distant lawn—of which the photographer may have been oblivious when exposing the negative.[9]

A friend of Dickens and Collins, C. H. Townshend (1798–1868), was among the most notable early connoisseurs of fine photographs, and collected one of the earliest known "scene of the crime" series. These images, occasioned by the Clerkenwell Explosion that took place in London in 1867, were made on speculation for sale by or for the photographic print dealer Henry Hering. In one photograph, detectives and police survey the evidence after a bomb blast—Irish Fenians laid explosive charges against the wall of a prison in an attempt to free comrades inside (fig. 2). Using a magnifying glass, one can see that there are figures watching from the roof above and to the right. The photographic description is minute enough to allow us—just—to distinguish between the similar forms of collapsing chimneys and figures in stovepipe hats. It shares with the Weegee a superfluity of information—an invitation to deductive speculation.

An extraordinary observer of telling details, Sir Arthur Conan Doyle's Sherlock Holmes could, with justice, be termed the most *optical* of detectives. He follows in the tradition of Poe's M. Dupin and the line of English detectives and observers notable for their implacably functional perception. Holmes is described in the first paragraph of Conan Doyle's short story *A Scandal in Bohemia* (1892) as "the most perfect reasoning and observing machine that the world has seen." Like the omnivorous camera Holmes takes in all around him and commits it to memory, effectively short-circuiting his own subjective responses and allowing significant data to assert themselves within his consciousness. Raymond Chandler's detectives also have eyes

FIG. 13
Attributed to Henry Hering
The Clerkenwell Explosion
1867
Collection of the Victoria and Albert Museum

Room 623 of Coney Island's Half Moon Hotel
was where Abe Reles (see plate 66), a hit
man for the crime syndicate Murder Inc.,
was staying under police guard prior to
the group's trial. Reles was pushed out
of this window to prevent his testimony,
but his death was made to look accidental—
as though he had fallen while trying to
escape to the room below on a rope of
knotted-up sheets.

like machines. Captain Cronjager in *The Big Sleep* (1939) is described by the story's dectective, Philip Marlowe, as "a cold-eyed hatchet-faced man, as lean as a rake and as hard as the manager of a loan office. His neat well-kept face looked as if it had been shaved within the hour. He wore a well-pressed brown suit and there was a black pearl in his tie." Introduced to Philip Marlowe, Cronjager "looked me over as if he was looking at a photograph." This last line raises the question: how is it exactly that we look at a photograph? First, obviously we see the photograph as something inanimate that cannot respond to our gaze, and second, we recognize the photograph as something to be scanned, surveyed, examined all over, for any scrap of evidence. We might find ourselves looking at the mug shots in this exhibition in the same conjectural manner as Marlowe does in *The Big Sleep*:

He pushed a shiny print across the desk and I looked at an Irish face that was more sad than merry and more reserved than brash. Not the face of a tough guy and not the face of a man who could be pushed around much by anybody. Straight dark brows with strong bone under them. A forehead wide rather than high, a mat of dark clustering hair, a thin short nose, a wide mouth. A chin that had strong lines but was small for the mouth. A face that looked a little taut, the face of a man who would move fast and play for keeps. I passed the print back. I would know that face, if I saw it. (Chap. 20)

Marlowe is endowed with the same heightened faculty of observation that identifies a Baltimore detective in *Farewell My Lovely* (1940)—a "camera eye as rare as a pink zebra" (chap. 41).

Photographic vision is endemic to detective fiction not only on the page but also on the screen. Take, for example, the celebrated sequence in Ridley Scott's *Blade Runner* (1982), in which—following a succession of camera zooms—a tiny clue is found buried deep in a photograph at the back of a room. In Elmore Leonard's *LaBrava* (1983), ex-police photographer Joe LaBrava knows his photography, from *Aperture* to Weegee, and has shown some of his works in galleries, but what piques our interest is the way he follows uncannily in the line we have been tracing from the time of Dickens. Like Dickens, when "Joe walks down the street he knows everything that's going on. He picks faces out of the crowd, faces that interest him. It's a habit, he can't quit doing it" (chap. 1). Surprisingly, our

story continues into the world of William Gibson, creator of the term "cyberspace." Chapter 12 of *Virtual Light* (1993) is called "Eye movement." The hero—Rydell—meets two San Francisco cops:

They both had that eye thing, the one that pinned you and held you and sank right in, heavy and inert as lead. Rydell had had a course in that at the Police Academy, but it hadn't really taken. It was called Eye Movement Desensitization & Response

The detective's eye functions like a camera, taking in everything and leaving upon his mind something akin to a photographic image. Neither photographs nor detectives are necessarily respecters of "good form": both practice what is at best a kind of staring, and at worst crude voyeurism. Our pleasure in looking at photographs derives in part from the license they give us to stare fixedly and unselfconsciously at something. Although we may be highly alert to graphic structure and tonal nuance, when we look at photographs our primary impulse is to browse, to sweep for content, corner to corner, observing, deducing, actively evaluating evidence. As Lady Eastlake realized, it is this evidential core that makes a photograph distinct from any other kind of representation. The prospect we all relish of finding some telltale sign, the mute, hidden part that unlocks the whole, is nowhere better illustrated than in Chandler's *The High Window* (1943), where in the pivotal scene Marlowe becomes absorbed in a photograph depicting a window and the elusive clue he knows it must contain:

There I was holding the photograph and looking at it. And so far as I could see, it didn't mean a thing. I knew it had to. I just didn't know why. But I kept on looking at it. And in a little while something was wrong. It was a very small thing, but it was vital. The position of the man's hands, lined against the corner of the wall where it was cut out to make the window-frame. The hands were not holding anything, they were not touching anything. It was the inside of his wrists that lined against the angle of the bricks. The hands were in the air.

The man was not leaning. He was falling. (Chap. 29)

NOTES

1. My earlier thoughts on this theme appear in "The Dawning of an Age: Chauncy Hare Townshend, Eyewitness," in *The Golden Age of British Photography, 1839–1900* (New York: Philadelphia Museum of Art, in association with Aperture, 1984); "A Connoisseur of the Art of Photography in the 1850s: The Rev. C. H. Townshend," in *Perspectives on Photography: Essays in Honor of Beaumont Newhall*, ed. Peter Walch and Thomas Barrow (Albuquerque: University of New Mexico Press, 1986); "Dickens, Detectives and Photography," in *Les Multiples Inventions de la Photographie*, ed. Pierre Bonhomme (Paris: Mission du Patrimoine Photographique, 1989).

2. Carlo Ginzburg, "Morelli, Freud and Sherlock Holmes: Clues and Scientific Method," in *History Workshop* (Spring 1980). The article is reprinted in Ginzburg, *Myths, Emblems, Clues* (London: Hutchinson Radius, 1990), 96–125.

3. Ginzburg, 24.

4. This draft is now in the National Art Library at the Victoria and Albert Museum, London.

5. Ian Ousby, *Bloodhounds of Heaven: The Detective in English Fiction from Godwin to Doyle* (Cambridge, Mass., and London: Harvard University Press, 1976), 80–110.

6. Philip Collins, ed., *Dickens: The Critical Heritage* (London: Routledge and Kegan Paul, 1971), 390–401

7. Ibid., 190.

8. Reprinted in Beaumont Newhall, ed., *Photography: Essays and Images: Illustrated Readings in the History of Photography* (New York: The Museum of Modern Art, 1980), 93–94.

9. William Henry Fox Talbot, *The Pencil of Nature* (London: Longman, Green and Co., 1844–46).

The net paid circulation
for June exceeded
Daily---1,500,000
Sunday-2,150,000

DAILY NEWS

NBA CODE

FINAL

Copyright 1934 by News Syndicate Co., Inc. Reg. U. S. Pat. Off.
NEW YORK'S PICTURE NEWSPAPER
Entered as 2nd class matter, Post Office, New York, N. Y.

Vol. 16. No. 24 48 Pages New York, Tuesday, July 24, 1934★ 2 Cents IN CITY 2 CENTS LIMITS 2 CENTS Elsewhere

DILLINGER GIRL
TO GET $15,000

Story on Page 3.

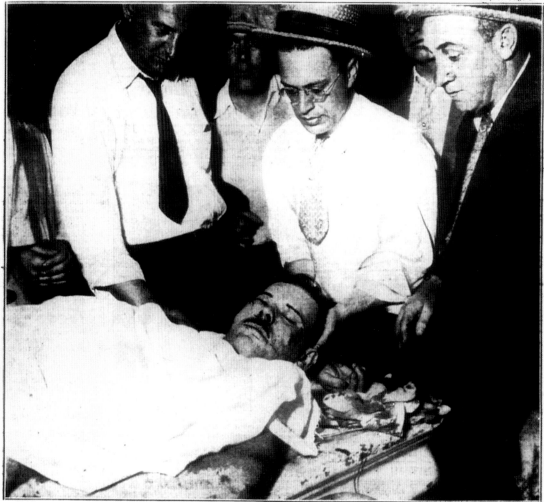

The trail of John Dillinger, which wound a gory pattern across the continent, came to an end on this slab in the County Morgue in Chicago. Led by a woman into a Federal trap, the nation's Public Enemy No. 1 was shot to death by Government agents in front of a Chicago theatre. His close-cropped mustache and gold-rimmed spectacles failed to conceal his identity. A red-gowned Delilah, who sold him out for $15,000, was being closely guarded last night by police. —Story p 3; other pics. pages 24 and 25.

"AND SO THE MOVING TRIGGER FINGER WRITES"

Dead Gangsters and New York Tabloids in the 1930s

Carol Squiers

The modern American tabloid newspaper was launched in New York City in 1919; it offered a model for the way in which news was conceived, reported, and illustrated in newspapers across the United States, an influence that continues to be felt today. The tabloid was poised to exploit the social changes that occurred in the United States after World War I, although that exploitation was often accomplished under the guise of moralistic critique. Tabloids gleefully reported on the new sexual permissiveness and increasing freedoms for women, the forbidden charms of speakeasy culture, and the celebrity gangsters who populated the criminal enterprises created by Prohibition. The latter in particular offered fertile ground for melodrama and sensationalism, and the tabloids succeeded at once at publicizing and glamorizing gangsters while maintaining a posture of outrage and shock at their exploits. One contemporary press critic, journalist Silas Bent, called the

journalism of the era "ballyhoo," reportage that feeds "an abnormal appetite for sensation."[1]

This appetite had been nourished by American news coverage for at least a century, starting with the downmarket penny papers of the 1830s. But with their screaming headlines, overheated prose, and lavish use of photographs, tabloids magnified and reconfigured the dissemination of scandal, gossip, and crime. Photographs were a particularly powerful vehicle for creating vivid, larger-than-life characters that would arouse more interest—and sell more newspapers—than well-reasoned reporting ever could. With few prohibitions about what could be published, editors used pictures that were surprisingly graphic, especially when reporting on crime. Those images reached a peak of bloody explicitness in the mid-1930s, when federal law enforcement officials began a campaign to publicize their might. The tabloids had an unsavory reputation even then, but they proved to be the perfect vehicle to broadcast law-and-order messages in the form of moral tales.

Crime, and specifically photographs of big-time criminals, was a major ingredient in the frenzied maelstrom of sensationalism that defined tabloid newspapers in New York. As a news topic, crime was not the creation of the tabloids, or even the penny papers, for it had been a part of news reportage even before the invention of newspapers.[2] But shootouts, killings, robberies, and kidnappings assumed a new importance in the 1920s and 1930s with the rise of the Prohibition-era gangster, especially in the tabloids. By 1926, according to one survey, the New York *Daily News*—the largest-circulation American tabloid—was devoting over 33 percent of its editorial space to crime news, far outstripping the already large percentage of crime news (10.7 percent in 1925) that was being printed by all types of daily newspapers.[3]

In the 1920s, the type of crime reportage that grabbed the public's attention was the sensational

murder trial—the Fatty Arbuckle trial, the Leopold-Loeb trial, the Hall-Mills trial, the Snyder-Gray trial.[4] As the 1920s closed, what drew public fascination was not a trial but a bloodbath, one of Gangland's most infamous crimes: the St. Valentine's Day Massacre on February 14, 1929 (fig. 16). Seven members of the Bugs Moran gang were mowed down in a Chicago garage by machine gun-toting men, some dressed as police officers. This hit on mob rivals, ordered by the ambitious Al Capone, ushered in a new round of gang violence and a high-profile response to it by law enforcement. It also took some of the luster off the glamorous image of the gangster, particularly Capone. During the coming decade, individual murder trials were overshadowed in the public eye by a series of summary street executions in which gangsters were killed by gangsters, as well as by the forces of the law.

Street-level violence was one of the major narratives of the cultural landscape in the 1930s, the decade that saw the creation of the "public enemy"—a term coined by the Chicago Crime Commission and popularized by the press—and his very public downfall.[5] Lawlessness of all types preempted much other news in the tabloids, including reportage of the Great Depression (with the exception of labor strikes and strike-related violence), although in the latter 1930s, outlaws had to share coverage with the rise of fascism in Europe.

Still photographs played an essential role in vividly illustrating crime in this pre-television era, but most of these images have been forgotten. The only body of crime photography from the 1930s that is generally familiar is that by Arthur Fellig, a.k.a. Weegee, and recent scholarship reveals that most of his best-known crime images were taken in the 1940s.[6] However mistaken the notion, Weegee's artfully ironic and blatantly bloody images have come to define the popular idea of how crime was pictured between the world wars.

Unlike the confrontational, idiosyncratic images that Weegee made as a freelance photographer during this era, the New York tabloids of the 1930s deployed a standardized visual logic in representing crime. Most newspaper photos were taken either

FIG. 15 [PAGE 40]
Front page of the July 24, 1934, issue of the *Daily News*
Courtesy of New York Daily News, L.P.

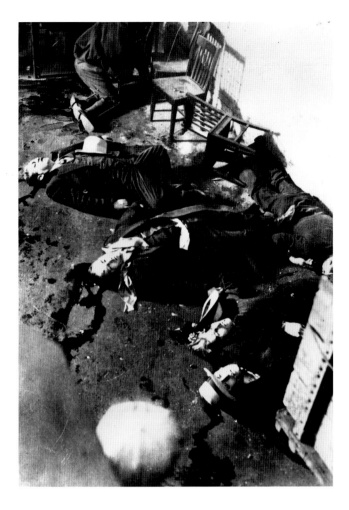

FIG. 16
International News Photos
St. Valentine's Day Massacre
1929
Courtesy of UPI/Corbis-Bettmann

at a further remove from the subject than were Weegee's, or so close up as to look almost clinical. Where Weegee would capture telling details at the scene of the crime—a dead man's face smashed on the pavement, glasses broken—the average tabloid photographer treated crime victims more as uninflected objects around which law enforcement officials might importantly gather.[7]

Although the visual fact of a murdered body was in itself shocking, the choice of which victims to portray was calculated to provoke maximum outrage. This meant that the bodies of children and young women might be shown, whereas a story on three thugs found in the trunk of a car would go unillustrated. Pictures of the uncovered corpses of three young girls found in a wooded area in Pennsylvania, for instance, appeared on at least three separate days in the *Daily Mirror*.[8] Both the *Mirror* and the *Daily News* printed pictures of the girls on display in a funeral home, while people

trooped by, supposedly trying to identify them.[9]

Each of the tabloids shaped its pictorial illustrations to fit its own editorial style. They shared, however, certain essential precepts about what was desirable and even necessary in a crime photograph. Some crimes were extravagantly illustrated, and included images of everything from suggestive pieces of evidence (a single, woman's glove) to bloody bodies. Other stories were accompanied only by a simple identifying headshot, although the crime was described in florid detail.

There were three tabloid newspapers in New York at the beginning of the 1930s. The *Daily News* was the original and most successful of them and was published by Joseph Medill Patterson, a controlling partner in the *Chicago Tribune*. After its June 26, 1919, debut, the *Daily News* inspired the founding of small illustrated newspapers throughout the United States. Although the term "tabloid" originally referred only to a small page size, the essence of what we know as tabloid journalism came to mean that it was also liberally embellished with photographs and written in a colorful, evocative, and even exaggerated style.[10] From the start, the *Daily News* targeted working-class New Yorkers with a formula that included using photographs to fill more than half of the nonadvertising space. By mid-1922 the *News* "was selling a half-million copies a day and was the nation's largest newspaper."[11] It passed the million-reader mark in 1925.[12]

The success of the *Daily News* led William

Randolph Hearst to launch a competitor, the New York *Daily Mirror*, on June 24, 1924. As he had done in the past, Hearst "copied his established rival's headlines, pictures, and features."[13] But the paper, which was even more sensational than the *News*, never rivaled the older paper in circulation; by mid-1925 the *Mirror*'s circulation was a mere 218,431, less than one-quarter of the *News*'s.[14]

On September 15, 1924, the city's third tabloid was born. The peculiar New York *Evening Graphic* was the brainchild of Bernarr Macfadden, who also published true confession and health and body building magazines. The influence of both genres can be seen in the *Graphic*, along with outrageous sensationalism and an abundance of scantily clad women. The paper only lasted eight years, during which time it was dubbed the *Porno-Graphic* and was "denounced, derided, damned, and sued, not only for libel but also for obscenity."[15] Its circulation peaked at 335,000 in 1928, well behind the *Daily News*.[16]

One thing particularly noteworthy about the *Graphic* was its penchant for creating posed and/or composite photographs, which it called *composographs*. Although the manipulation of pictures, including liberal retouching, was not unprecedented at the time, the *Graphic* was the only paper that doctored photographs consistently and openly as a matter of policy.[17] In terms of violent imagery, though, the *Graphic* would seem to have had little need to invent; there were plenty of sensational photographs available that were genuine. Explicit images were regularly printed of dazed and bloodied car-crash victims, the cold corpses of ordinary citizens, and the bullet-pocked torsos of gangsters. In 1933, even Hollywood acknowledged the weird power and central role of the crime photographer by conflating an ex-convict and a tabloid photographer into one character, played by James Cagney, in the movie *Picture Snatcher*.[18]

Crime reportage, not surprisingly, was to a large extent imaged in terms of the body. The gangster's body was depicted as an entity at once threatening and debased, fabricated within broad stereotypical categories of representation to show the criminal as captured, dangerous, shamed, punished, or

murdered. Property crime was reported on as well, but an image of two detectives peering into an empty safe didn't carry nearly the emotional weight of a shot-riddled "public enemy"—or a young thug's sobbing mother. Static images of "evidence" or "the scene of the crime," however, could be used to build visual constructions to convey the magnitude of a crime, and therefore the evil of the criminal who committed it.

The most dramatic of the decade's crime photographs show the corpses of famous gangsters, often in explicit detail. Whether the criminals had been killed by the authorities or by outlaw competitors, the police were eager to expose the headline-making gangsters, bank robbers, and kidnappers to public scrutiny and disapprobation, thus providing a boon to the hungry tabloids. And it didn't matter who had pulled the trigger: lawmen were always happy to pose with a headline-worthy corpse. The tabloids's rationale for reproducing explicit images was based on their ability to promote the gangster as the reviled "other." His (and sometimes, her) transgressions thus demanded, or at least permitted, the obsessive scrutiny of the camera.

The most lavishly publicized string of government-issue gangster deaths occurred in 1934, by which time there were only two tabloids in New York, the *Evening Graphic* having folded in 1932. The highest-profile killing was of John Dillinger, who was shot by federal agents and East Chicago police outside the Biograph movie theater in Chicago on July 22. He had been declared "Public Enemy No. 1" by the Department of Justice because of a series of lucrative small-town bank robberies he and his cohorts had committed throughout the Midwest, and for his general ability to outwit the law, which included jail breaks and raids on police stations to equip his troops.

The reportage on Dillinger's demise established not only the justice of his death, but the pretext for its public celebration. "A monstrous freak was the attraction here today—a cross between a mad-dog and a cobra. It went by the name of John Dillinger and it walked like a man until dead. It was placed on exhibition today in the old morgue," wrote an

FIG. 17
International News Photos
John Dillinger on a Stretcher
1934
Courtesy of UPI/Corbis-Bettmann

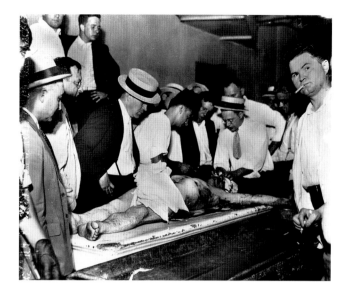

FIG. 17
International News Photos
John Dillinger on a Stretcher
1934
Courtesy of UPI/Corbis-Bettmann

unidentified reporter in the *Daily Mirror*. He added that the exhibition of the body was only for "accredited officials and newspaper men," the latter being the proxies for the supposedly outraged public that awaited visual proof of the law's rectifying power.[19]

The press' access to this event resulted in the publication of at least eight different photographs of the deceased Dillinger, who was shown clothed and unclothed and from a variety of angles and in different settings. Both at the scene of the shooting and at the morgue, news photographers appear to have had substantial freedom to work.

Among the published images of Dillinger's corpse was one of his body unceremoniously laid on the floor of a police wagon with a detective hovering over it.[20] Another image, a close-up side-view of his face taken in the morgue, purported to show how he had tried to use plastic surgery to disguise himself. Still another morgue shot shows a large group of men—at least fifteen are visible in the picture—gathered around while two portly officials take Dillinger's fingerprints, which "soon set at rest forever" rumors that the deceased was not Dillinger—rumors that persist to this day.[21]

The payoff images, for the tabloids, were the ones of the outlaw on the "slab" at the morgue. The *Daily News* version showed Dillinger's cadaver covered to the chin with a sheet, with blood-stained rags lying nearby. Shot at an angle, from the waist up, the photograph depicts Dillinger's head cradled by a bespectacled man while other men—all of

them unidentified—look on.[22] This bold image took up nearly two-thirds of the front page (fig. 15).

Not to be outdone, the *Daily Mirror* used an even more graphic image on its front page, but ran it smaller. In this instance, the photographer pulled back to show Dillinger's entire body lying on the same slab, nude, with his arms and legs stretched out, his genitals covered by a wadded-up sheet. Here the men seem to ignore the camera as they bend over the corpse (fig. 17).[23]

Once so powerful at inspiring headlines and eluding capture, Dillinger has been thoroughly defeated and can thus be subjected to any indignity; one newspaper mentioned that the men in the pictures all kept their hats on as a sign of disrespect. The persistent photographic scrutiny of the broken and denuded Dillinger corpse served as a way of symbolically apprehending him again, emphasizing his ultimate vulnerability—both to the law and to the press—and replacing his former image of daring and contempt for authority with one of complete destruction.

While the justice of Dillinger's demise may have been bestowed by the conscientious workings of the law, his death was framed by the betrayal of a woman. "Girl Sold Dillinger for $15,000 Reward," proclaimed the headline on a story that began: "A $15,000 Gangland Delilah in a red dress put the finger on John Dillinger last night—clipped the locks of the Samson of crime and betrayed him into the range of the guns of the law."[24] This initially

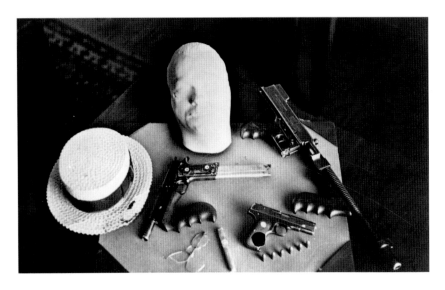

FIG. 18
Unknown
Death mask of John Dillinger and other items on exhibit at FBI Headquarters
n.d.
Courtesy of the FBI

unnamed woman, who brought Dillinger to the movie theater where the ambush took place, was one of a huge cast of "gun molls," "gangster's sweethearts," and other morally damaged women who populated the pages of the tabloids. These women were twice corrupted, first by the loose ideals of the recently enfranchised, short-skirted modern woman, and then by the gangsters with whom they consorted. That a woman had helped bring down Dillinger added a second level of meaning to the story of his fall, one that thus ridiculed his manhood while he lost his life.

The Dillinger kill generated tremendous publicity for J. Edgar Hoover and his "G-men"; Hoover was so proud of this achievement that he kept

Dillinger's cigar, straw hat, broken glasses, .38-caliber pistol, and death mask on display in his reception room for decades (fig. 18).[25] After this success, similarly spectacular hunt-and-kill strategies were deployed for destroying other bank robbers. Charles Arthur "Pretty Boy" Floyd, who may have been involved in at least ten murders, and George "Baby Face" Nelson were both named public enemies after Dillinger's demise, although their deaths were less symbolically significant to law enforcement and to the press than Dillinger's was.[26]

Thus, the press didn't examine their corpses as avidly as it had in the Dillinger case, contenting itself mainly with dramatic morgue shots. In the case of Pretty Boy Floyd, for instance, Ohio

FIG. 19
Acme
"Pretty Boy" Floyd
1934
Courtesy of UPI/Corbis-Bettmann

The original caption, dated 10/23/34, reads "Residents of East Liverpool, Ohio, throng the morgue for a view of the body of Charles (Pretty Boy) Floyd, famous outlaw whose bullets blazed a crimson path over a dozen mid-western states. Floyd, Public Enemy No. 1 since the death of John Dillinger, was mortally wounded on an isolated farm near East Liverpool when he was surprised by Melvin Purvis of the Department of Justice, three of his agents, and four local policemen."

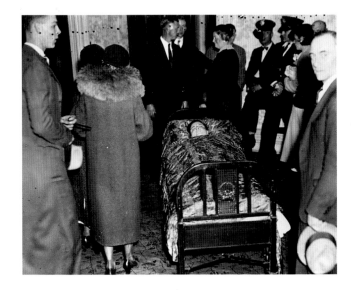

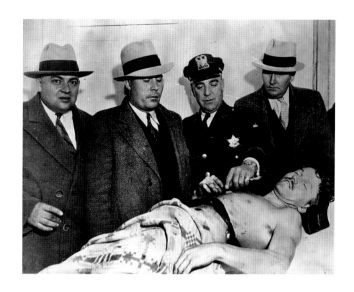

FIG. 20
Unknown
"Baby Face" Nelson
1934
Courtesy of Corbis-Bettmann

The original caption reads "Niles Center, Il: George 'Baby Face' Nelson, a member of the Dillinger gang, on an undertaker's slab after his assasination."

authorities made a bid for popular appeal by putting his body on public exhibition. Eerie images of ordinary citizens thronging around his cadaver in the East Liverpool, Ohio, morgue ran on the front page of the *Daily News* (fig. 19).[27] Ironically, the paper had also reported on a wire Floyd's mother had sent to the East Liverpool chief of police, asking him to "prevent any pictures being taken and bar the public," a request that reads like an unwitting guideline for subsequent events.[28] When Baby Face Nelson was shot down a month later, his bare-chested corpse, "riddled with seventeen bullets," and mouth frozen half open was displayed with policemen hovering triumphantly over the body and pointing out the bullet holes (fig. 20).[29] The *Daily Mirror* ran two other small images, one of his entire, unclothed corpse, in the Sunday edition of the paper three days later. [30]

The public relations success of this series of outlaw exterminations set the tone for stories on the next spectacularly executed gangster. This time it was a fellow racketeer who delivered the corpse, rather than the long arm of the law. The event was the 1935 Lucky Luciano-ordered hit on Arthur "Dutch Schultz" Flegenheimer and his "aides" after Schultz announced his intention to kill the crusading New York special prosecutor Thomas E. Dewey. Luciano feared this murder would draw unwanted attention to the racketeers, so he put out an order to silence Schultz. Along with three other gangsters, Schultz was gunned down in a Newark,

New Jersey, restaurant, while two of his associates were shot in a Manhattan barber shop. "And so the moving trigger finger writes…Gangland's guns, roaring finis to the career of thirty-one-year-old Arthur (Dutch Schultz) Flegenheimer, have signaled a new offensive in the endless warfare for control of New York City's rackets," wrote syndicated reporter Fred Pasley.[31]

The fact that gangsters were killing their own kind produced a note of levity in the reporting, amid the colorfully mordant prose the underworld inspired. "Gang War in Pictures!" was the sprightly back-page headline in the *Daily News*, heralding four bloody images of wounded mobsters, at least two of whom later died. Most demonstrative was Sammy Gold, a barbershop casualty, who in one image imploringly extends his clasped hands for the police to hurry to his aid. Another image depicts Gold waving off photographers from where he lies on the floor, blood-spattered and in pain. Much calmer is Leo Frank, who had been with Schultz. He is shown casually puffing on a cigarette in the hospital while waiting to be operated on. Perhaps the wait was too long: he never recovered.[32]

The primary focus of the reportage, however, was Schultz. In the best-known image of him after the shooting, he is shown slumped over a bloodied restaurant table, wearing an overcoat and a hat (pl. 65).[33] Although the fusillade had been powerful, Schultz did not succumb for two days, and was repeatedly photographed as he lay awaiting medical

3. John R. Brazil, citing a statistical survey by Joseph L. Holmes, in "Murder Trials, Murder, and Twenties America," *American Quarterly* (Summer 1981): 165; Bent, *Ballyhoo*, 211.

4. Brazil, 163.

5. David E. Ruth, *Inventing the Public Enemy: The Gangster in American Culture* (Chicago: The University of Chicago Press, 1996), 2. The concept of the "public enemy" was announced on April 23, 1930.

6. Miles Barth, curator of archives and collections at the International Center of Photography, found the dates of many Weegee crime photos to be incorrect. See his important essay, "Weegee's World," in the catalogue that accompanies the exhibition *Weegee's World: Life, Death, and the Human Drama* at the International Center of Photography, November 21, 1997–February 22, 1998. My thanks to Barth for generously sharing his knowledge of Weegee with me.

7. For Weegee's point of view on how he tried to differentiate his images from those of other news photographers of the time, see Rosa Reilly, "Free-Lance Cameraman," *Popular Photography* (December 1937): 21–23, 76–79. My thanks to Melissa Rachleff for supplying me with a copy of this article.

8. *Daily Mirror*, November 25, 1934, 2; November 26, 1934, 3; November 30, 1934, 3.

9. *Daily Mirror*, November 27, 1934, back page; *Daily News*, November 27, 1934, 1.

10. Frank Luther Mott, *American Journalism: A History of Newspapers in the United States through 250 Years, 1690 to 1940* (New York: The Macmillan Company, 1941), 666, 673.

11. John D. Stevens, *Sensationalism and the New York Press* (New York: Columbia University Press, 1991), 125. For facts on the New York tabloid press I rely heavily on Stevens, as he is the only historian to have studied the topic in depth.

12. Stevens, 185. *Daily News* circulation reached two million by 1933, and in 1938 the *News* was selling three million copies a day.

13. Stevens, 132.

14. Stevens, 136.

15. Stevens, 137, 139. Typical *Evening Graphic* headlines included "Half-Mad Bluebeard Taught Rites of Sex to 115 Sex-Starved Women," September 1, 1931, 3; and "Sheik Admits Orgy with Corpse," September 10, 1931, 1.

16. Stevens, 142.

17. Stevens, *Sensationalism and the New York Press*, 141. Also see Lester Cohen, *The World's Zaniest Newspaper: The New York Graphic* (Philadelphia: Chilton, 1964), 95–136.

18. Ruth, *Inventing the Public Enemy*, 173.

19. *Daily Mirror*, July 24, 1934, 3.

20. *Daily News*, July 24, 1934, 24–25.

21. *Daily News*, July 24, 1935, 24–25. The rumors that Dillinger had not been killed were revived again in 1970 with the publication of Jay Robert Nash's *The Dillinger Dossier* (Highland Park: Illinois, 1970), in which he pointed out discrepancies between the autopsy report on Dillinger and the known physical characteristics of the man. For a summary of Nash's argument see Anthony Summers, *Official and Confidential: The Secret Life of J. Edgar Hoover* (New York: G. Putnam's Sons, 1993), 73.

22. *Daily News*, July 24, 1934, 3-star final, 1.

23. *Daily Mirror*, July 24, 1934, 1; also used in *Daily News*, July 24, 1934, 3-star final, 3.

24. *Daily News*, July 24, 1934, 3-star final, 3.

25. Summers, 73. The pistol was apparently an added—and inauthentic—item.

26. For the most part, during the 1930s Hoover confined the activities of his agents to pursuing bandits and murderers like Dillinger and Floyd, who operated in small gangs. He ignored the members of the crime syndicates that organized into what was known as Cosa Nostra or the Mafia, except for some sweeps against Italian gangsters in 1957, which abruptly halted. Suggested reasons for his reluctance to pursue crime syndicate members include the fact that the Mafia had compromising information about Hoover's sexual preferences, including incriminating snapshots, that they used to render him ineffective. See Summers, *Official and Confidential*, 225–59.

27. *Daily News*, October 24, 1934, 1.

28. *Daily News*, October 23, 1934, 4-star final, 4. The corpse of Bonnie Parker had also been on public view, albeit at a funeral home, which may have been what spurred Floyd's mother's fears. See *Daily Mirror*, May 28, 1934, 16.

29. *Daily Mirror*, November 29, 1934, 1; *Daily News*, November 29, 1934, 1.

30. *Daily Mirror*, December 2, 1934, 2, 34.

31. Fred Pasley, *Daily News*, October 25, 1935, 38.

32. *Daily News*, October 24, 1935, 5-star final, 1, 72.

33. Instead of running this image, the *Daily News* printed one of a detective posing for the photographer in the position in which Schultz fell at the same, blood-covered table. *Daily News*, October 24, 1935, 4-star final, 2.

34. *Daily News*, October 24, 1935, 4-star final, 1; October 25, 1935, 1-star final, 1, 3, and 2-star final, 1, 3.

35. *Daily News*, October 25, 1935, 3-star final, 1.

36. Jay Robert Nash, *Bloodletters and Badmen: A Narrative Encyclopedia of American Criminals from the Pilgrims to the Present*, rev. ed. (1973; reprint, New York: M. Evans and Company, Inc., 1993), 201.

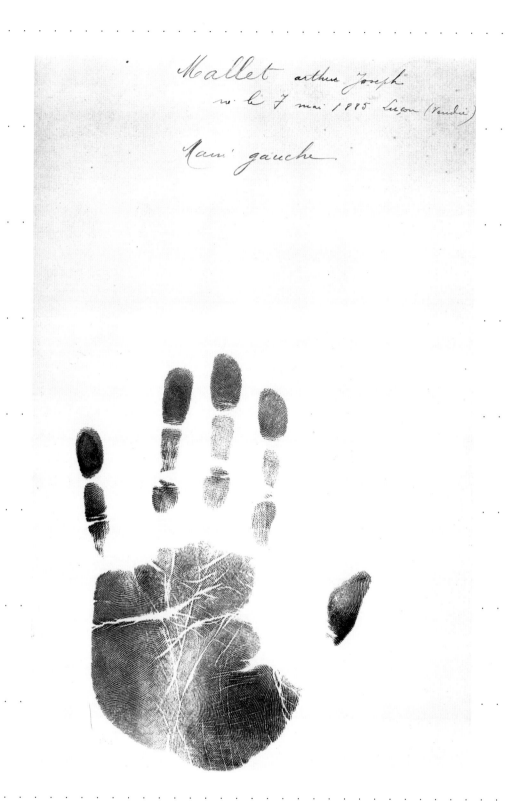

Mallet arthur Joseph
né le 7 mai 1885 Luçon (Vendée)

Main gauche

L'Empreinte de la main gauche d'Arthur Joseph
Mallet, né le 7 Mai 1885 (Print of the Left Hand
of Arthur Joseph Mallet, born May 7, 1885) n.d.
TITLE DATE

Unknown
PHOTOGRAPHER

Archives Historiques et Musée de la Préfecture de Police, Paris
COLLECTION

This handprint was used by Alphonse Bertillon in solving the
"Affaire de Thiais," a double murder committed in the Parisian
suburb of Thiais in January 1912. Using his novel system of
fingerprint identification, Bertillon was largely responsible
for identifying the perpetrators of this crime by matching
fingerprints found in the victims' house with those of people
already on file with the police department.

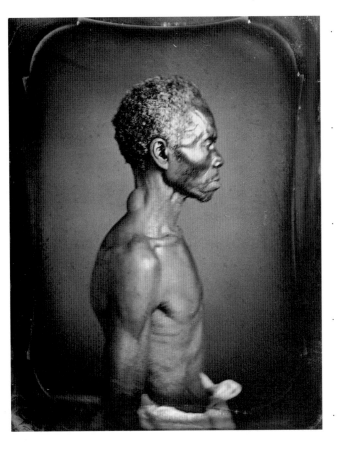

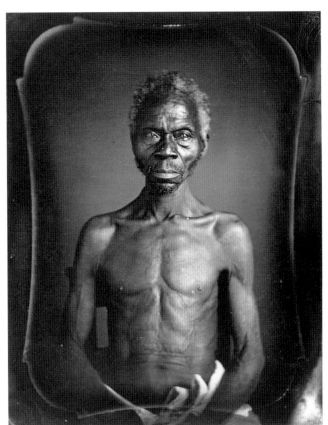

№. 0002

"Renty," Congo. On Plantation of
B. F. Taylor. Columbia, South Carolina 1850
TITLE DATE

J. T. Zealy
PHOTOGRAPHER

Peabody Museum, Harvard University
COLLECTION

№. 0003

"Renty," Congo. B. F. Taylor. Esq.
Columbia, South Carolina 1850
TITLE DATE

J. T. Zealy
PHOTOGRAPHER

Peabody Museum, Harvard University
COLLECTION

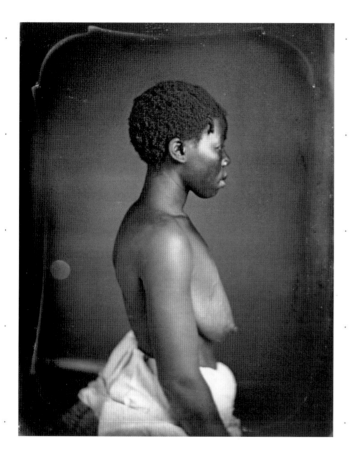 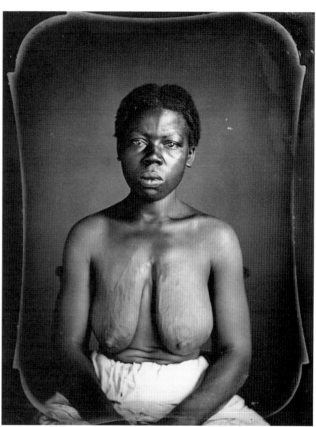

Nos. 0004, 0005

LEFT and RIGHT: *"Drana," Country Born, Guinea.*
Daughter of Jack. Plantation of B. F. Taylor.
Columbia, South Carolina 1850
TITLE DATE

J.T. Zealy
PHOTOGRAPHER

Peabody Museum, Harvard University
COLLECTION

These four daguerreotypes are part of a series made by J. T. Zealy
of Columbia, South Carolina, in 1850, for the use of Harvard
professor and naturalist Louis Agassiz. A "special creationist,"
Agassiz believed that the dissimilarities in mankind's races were
the result of different moments—as opposed to a single moment—of
creation, and that, therefore, all humans were not related as a
species. Presented in strict front and profile views to aid in
Agassiz's racial evaluation, these pictures resemble the mug shots
later used by police in their identification of criminals.

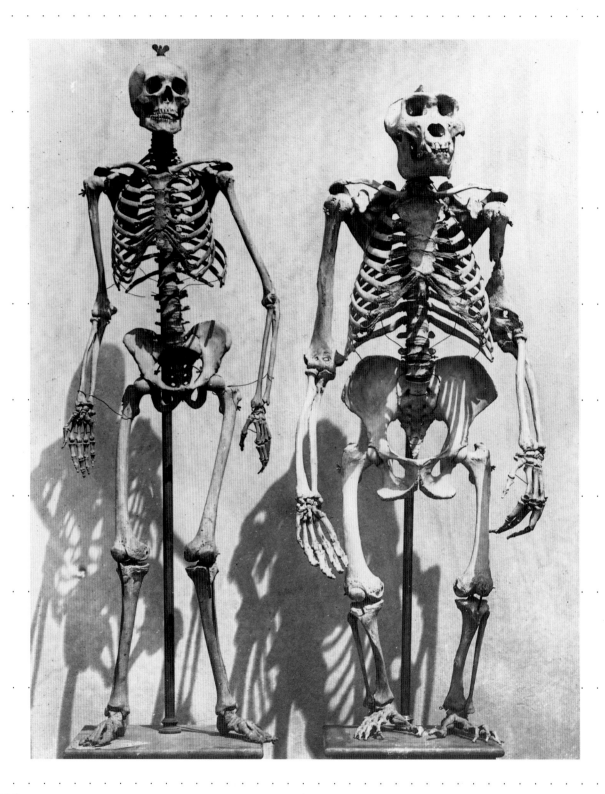

Skeletons of Man and Male Gorilla ca. 1857
TITLE DATE

Roger Fenton
PHOTOGRAPHER

Victoria and Albert Museum
COLLECTION

For several years in the 1850s Roger Fenton served as staff pho-
tographer for the British Museum, documenting works of art, antiq
uities, and objects of natural history to address the demand for
copies of works in the collection. This pairing of human and
gorilla skeletons illustrates Darwin's recently published theorie
and the resulting interest in the comparative analysis of anatomy

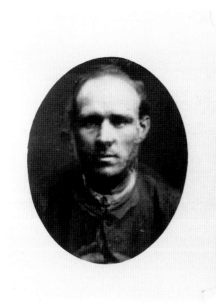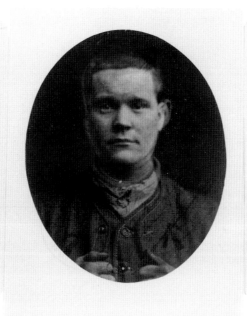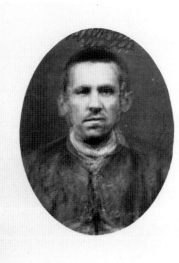

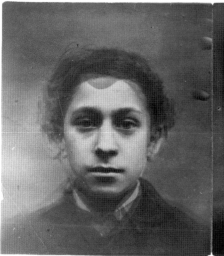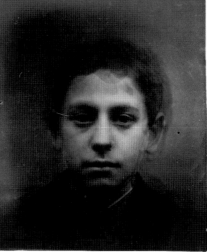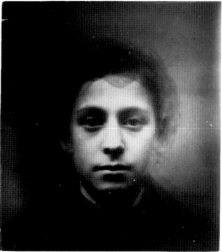

Nos. 0007, 0008

TOP: *Criminal Composites* 1870s
BOTTOM: *Jewish Composites* 1870s
TITLE DATE

Sir Francis Galton
PHOTOGRAPHER

Galton Papers, The Library, University College London
COLLECTION

Francis Galton, fearing the demise of both the upper classes and of the "highly evolved" white race, was interested in applying his cousin Charles Darwin's *The Origin of Species* to human eugenics. Galton also proposed that composite photography could be a useful tool in visualizing types or ideals such as the tubercular, the prize-winning racehorse, the Jew, and the criminal.

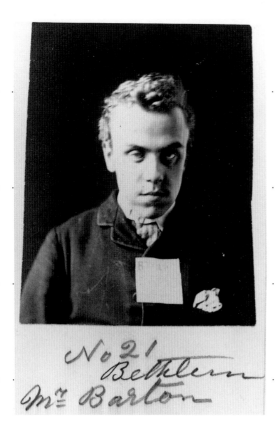

This is one of a series of photographs made to identify inmates of Bethlem Royal Hospital, a residence for the insane since 1400. During the nineteenth century, Bethlem housed the first English state asylum for the criminally lunatic.

This picture of a patient treated by Cesare Lombroso was used in his daughter's summary of his work to illustrate the "physical anomalies...characteristic both of criminals and epileptics" that led him eventually to conclude that "the criminal is only a diseased person, an epileptic, in whom the cerebral malady, begun in some cases during prenatal existence, or later, in consequence of some infection or cerebral poisoning, produces, together with certain signs of physical degeneration in the skull, face, teeth, and brain, a return to the early brutal egotism natural to primitive races, which manifests itself in homicide, theft, and other crimes."

[From *Criminal Man*, 72-73]

No. 0009

Mr. Barton, Resident of Bethlem Asylum 1870s
TITLE DATE

Sir Francis Galton
PHOTOGRAPHER

Galton Papers, The Library, University College London
COLLECTION

No. 0010

An Epileptic Boy, figure 14 of the book
*Criminal Man: According to the Classification
of Cesare Lombroso*, by Gina Lombroso Ferrero 1911
TITLE DATE

Unknown
PHOTOGRAPHER

San Francisco Museum of Modern Art
COLLECTION

ÉPILEPTIQUES.

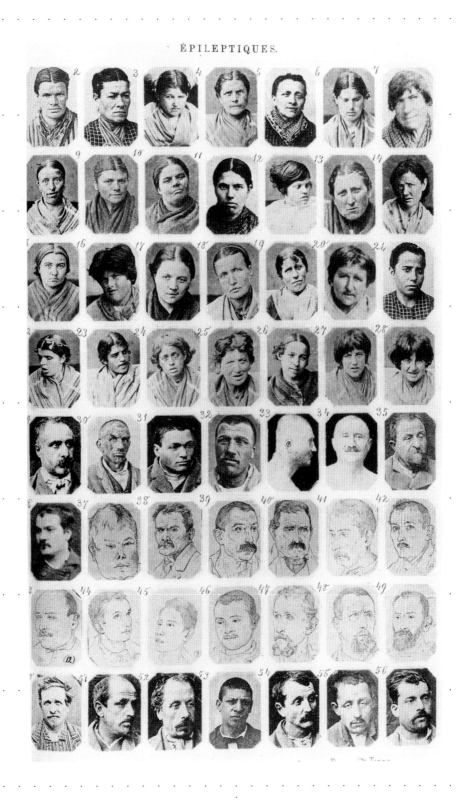

Epileptiques, plate XV of the book *L'Homme*
criminel (Criminal Man), by Cesare Lombroso 1887
TITLE DATE

Unknown
PHOTOGRAPHER
Special Collections, The Library and Center for Knowledge
Management, University of California, San Francisco
COLLECTION

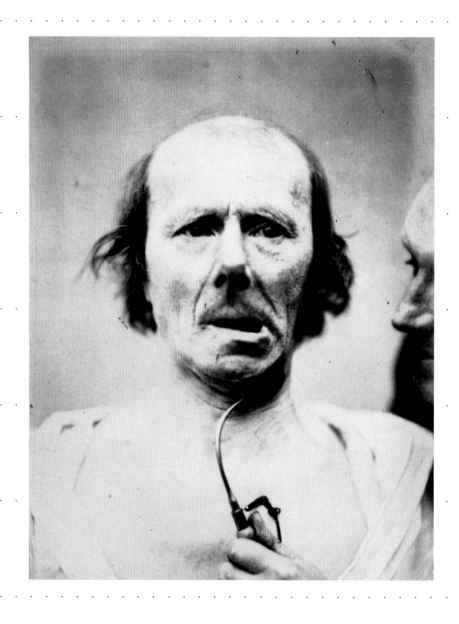

*Icono-Photographique: Mécanisme de la physionomie
humaine, Fig. 58* (Photographic Likeness: The
Mechanism of Human Facial Expression, Fig. 58) 1854
TITLE DATE

Guillaume-Benjamin Duchenne [known as Duchenne de Boulogne]
PHOTOGRAPHER

San Francisco Museum of Modern Art. Gift of Harry Lunn
COLLECTION

Duchenne de Boulogne was a physician who learned photography
in order to document his experimental application of electric
shocks to patients' faces. With these pictures he tried to
prove that facial expression is not individual but a universal
abstraction of emotion, unencumbered by personality. Charles
Darwin used these photographs to support his own study of the
biological purpose of expressions and their original, pre-
cultural meanings in man and animals.

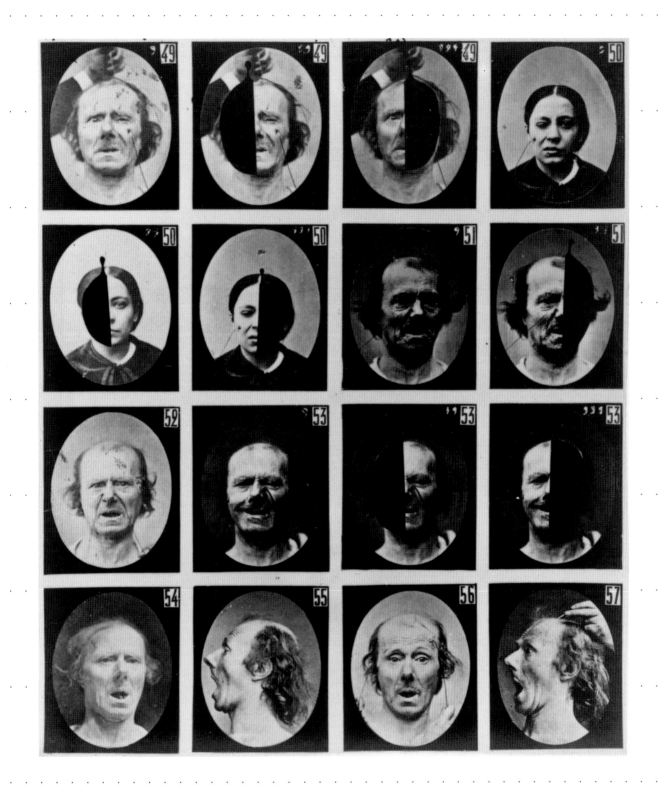

№. 0013

Plate illustration from the book *Mécanisme
de la physionomie humaine* (The Mechanism
of Human Facial Expression) 1876
TITLE DATE

Guillaume-Benjamin Duchenne [known as Duchenne de Boulogne]
PHOTOGRAPHER

Special Collections, The Library and Center for Knowledge
Management, University of California, San Francisco
COLLECTION

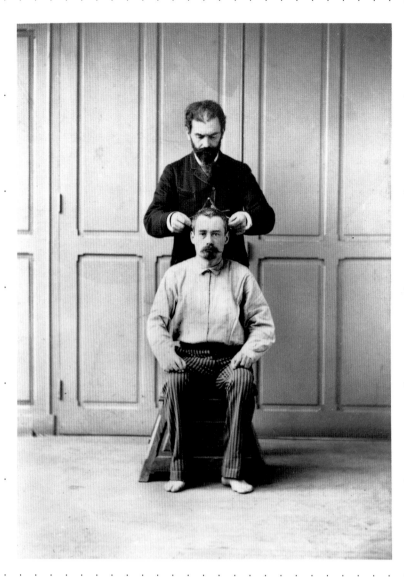

№. 0014

Mensuration du crâne (au visage plein)
(Measurement of Skull [Full Face]) n.d.
TITLE DATE

Alphonse Bertillon
PHOTOGRAPHER

Archives Historiques et Musée de la Préfecture de Police, Paris
COLLECTION

In the nineteenth century the social sciences of anthropology, ethnology, and sociology all gained serious acceptance and photography was often used to document studies in these fields. Alphonse Bertillon, the son of an important anthropometrist, urged the use of photography in police work. He invented the mug shot and the evidence photograph, and devised a system of measurements he believed would be unique to each individual and could serve as foolproof identification. He also experimented with fingerprints, which eventually supplanted his measurement system.

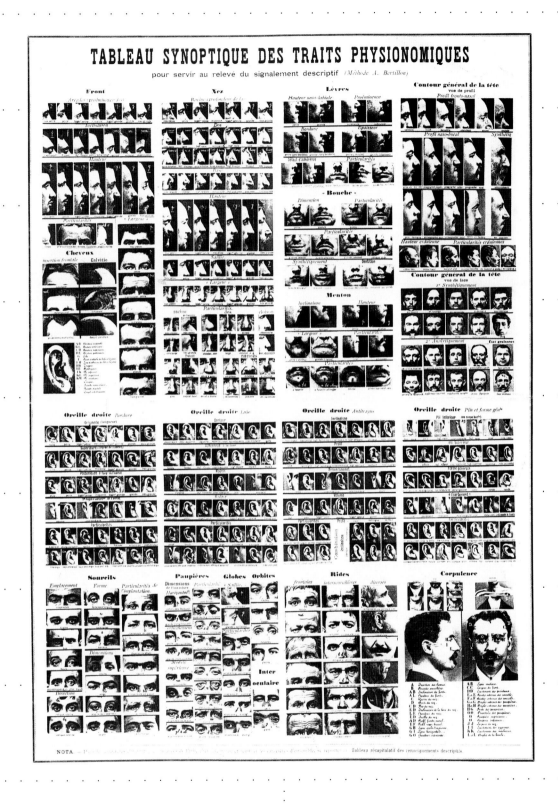

Tableau synoptique des traits physionomiques
pour servir au relevé du signalement descriptif n.d.
TITLE DATE

Alphonse Bertillon
PHOTOGRAPHER

Archives Historiques et Musée de la Préfecture de Police, Paris
COLLECTION

(Synoptic Table of Facial Expressions for the
Purposes of Systematic Identification)

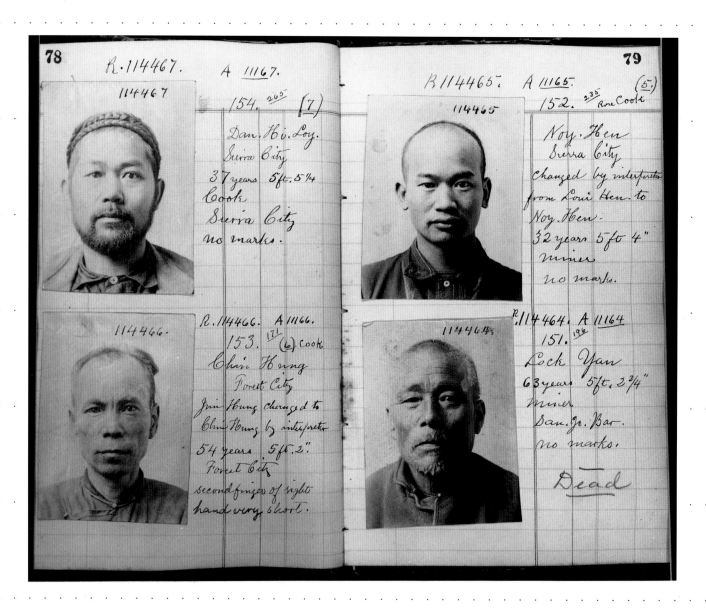

R. 114467. A 11167.

114467

154. ²⁶⁵ (7)
Dan. Ho. Loy.
Sierra City
37 years 5ft. 5¼
Cook
Sierra City
no marks.

R 114465. A 11165. (5)
152. ²³⁵ Rose Cook
114465

Noy. Hen
Sierra City
changed by interpreter
from Lowi Hen. to
Noy. Hen.
32 years 5ft 4"
miner
no marks.

114466.

R. 114466. A 11166.
153. ¹⁷¹ (6). Cook
Chin Hung
Forest City
Jim Hung changed to
Chin Hung by interpreter
54 years 5ft. 2".
Forest City
second finger of right
hand very short.

114464.

R. 114464. A 11164
151. ¹⁹⁶
Lock Yan
63 years 5ft. 2¾"
miner
Dan. Jo. Bar.
no marks.

Dead

No. 0016

*Chinese Photographed by D. D. Beatty with Brief
Biographical Descriptions by John T. Mason,
Justice of the Peace, Downieville, California* 1890
TITLE DATE

D. D. Beatty and John T. Mason
PHOTOGRAPHER

California Historical Society Library, San Francisco
COLLECTION

In 1874 war broke out between the U.S.
Government and the Modoc Indians of
Northern California, and after the latter's
defeat a series of portraits of the partici-
pants was made. These images reveal the
unfortunate position of Native Americans,
who were often seen as outsiders—and outlaws—
in their own land.

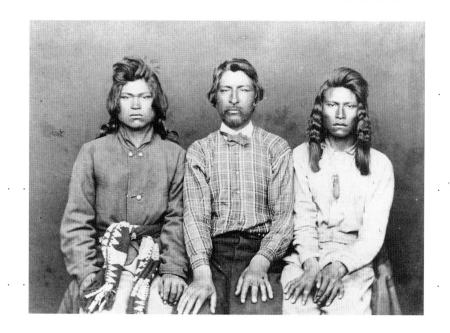

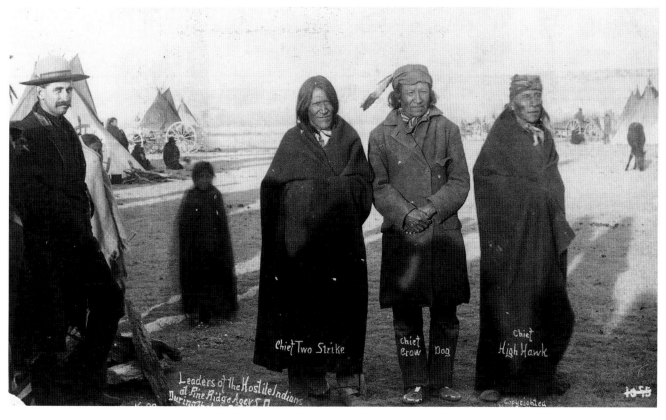

No. 0017

TOP: *Donald McKay and Jack's Capturers* 1873
TITLE DATE

L. H. Heller
PHOTOGRAPHER

Yale Collection of Western Americana,
Beinecke Rare Book and Manuscript Library
COLLECTION

No. 0018

BOTTOM: *Leaders of the Hostile Indians at Pine Ridge
Agcy., S.D., During the Late Sioux War: Chief Two
Strike, Chief Crow Dog, and Chief High Hawk* 1890-91
TITLE DATE

Lt. Butterfield
PHOTOGRAPHER

Yale Collection of Western Americana,
Beinecke Rare Book and Manuscript Library
COLLECTION

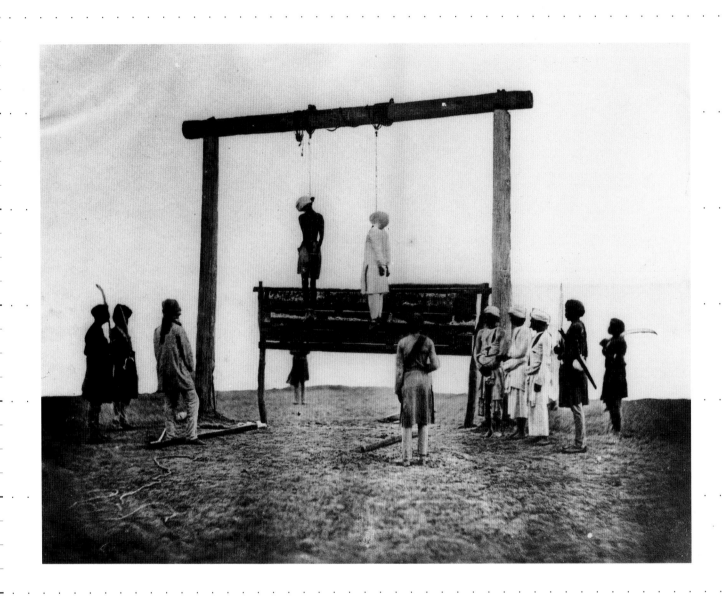

№. 0019

Untitled (Gallows on which two of the King of Delhi's
sons were hanged for having taken part in the murder
of the English residents at Delhi) 1857
TITLE DATE

Attributed to Felice A. Beato
PHOTOGRAPHER
Photography Collection, Harry Ransom Humanities
Research Center, The University of Texas at Austin
COLLECTION

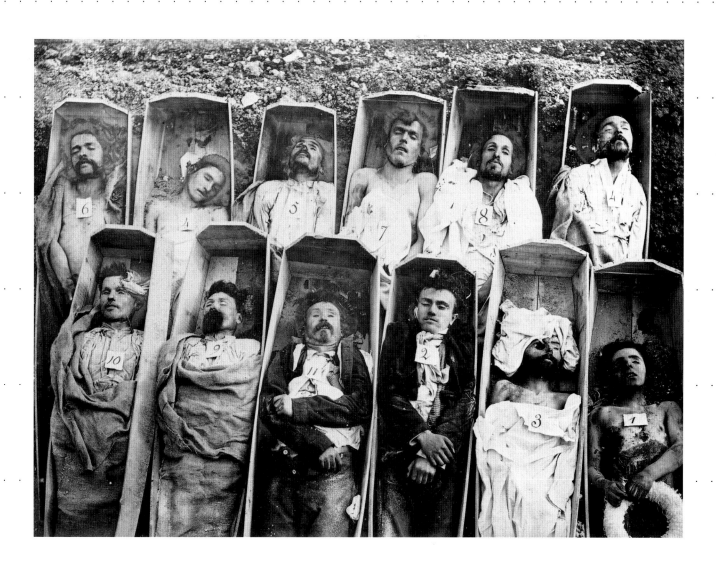

№. 0020

Insurgés non réclamés (Unclaimed
Insurgents), from a series of
photographs of the Paris Commune 1871
TITLE DATE

Unknown
PHOTOGRAPHER

Photography Collection, Harry Ransom Humanities
Research Center, The University of Texas at Austin
COLLECTION

During the Paris Commune of 1871, thousands of insurgents were
killed in street fighting or by execution. Their bodies were laid
out and numbered for identification, photographed, and then buried
in mass graves at Père Lachaise cemetery.

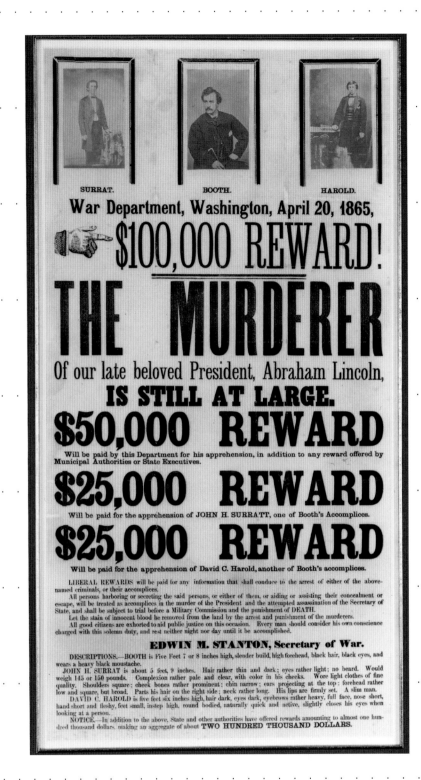

No. 0021

*$100,000 Reward! The Murderer of Our Late Beloved
President, Abraham Lincoln, Is Still at Large.* 1865
TITLE DATE

United States War Department
PHOTOGRAPHER

Albert H. Small
COLLECTION

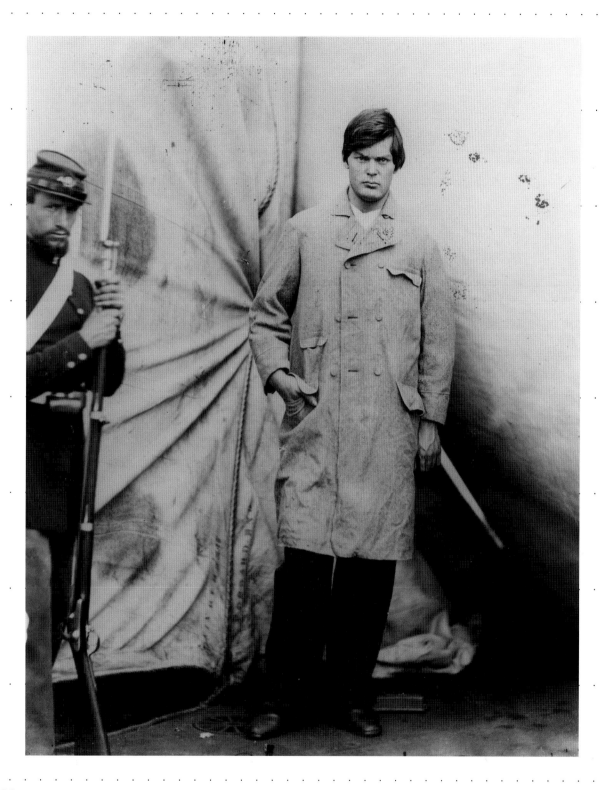

No. 0022

Lewis Paine, April 27, 1865 1865
TITLE DATE

Alexander Gardner
PHOTOGRAPHER

Gilman Paper Company Collection
COLLECTION

A co-conspirator with John Wilkes Booth in a plan to simultane-
ously assassinate Abraham Lincoln and Secretary of State William
Seward, Lewis Thornton Powell (alias Lewis Paine or Payne) was
unsuccessful in his attempt to stab Seward to death. Arrested
soon after the attempt, the twenty-year-old Powell was held
aboard an iron-clad monitor docked on the Potomac River, where
these pictures were taken. He was hanged three months later.

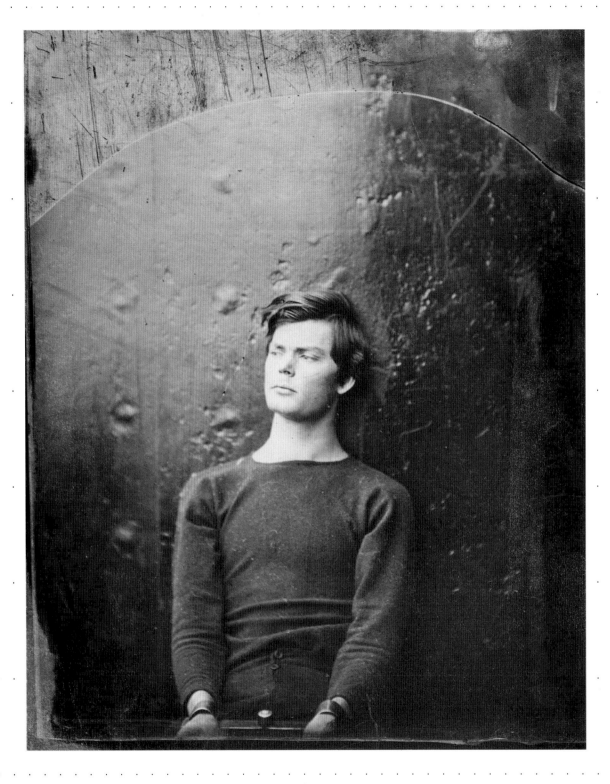

No. 0023

Conspirator Payne 1865
TITLE DATE

Alexander Gardner
PHOTOGRAPHER

San Francisco Museum of Modern Art. Purchased through a
gift of Shawn Byers and the Accessions Committe Fund, 97.44

COLLECTION

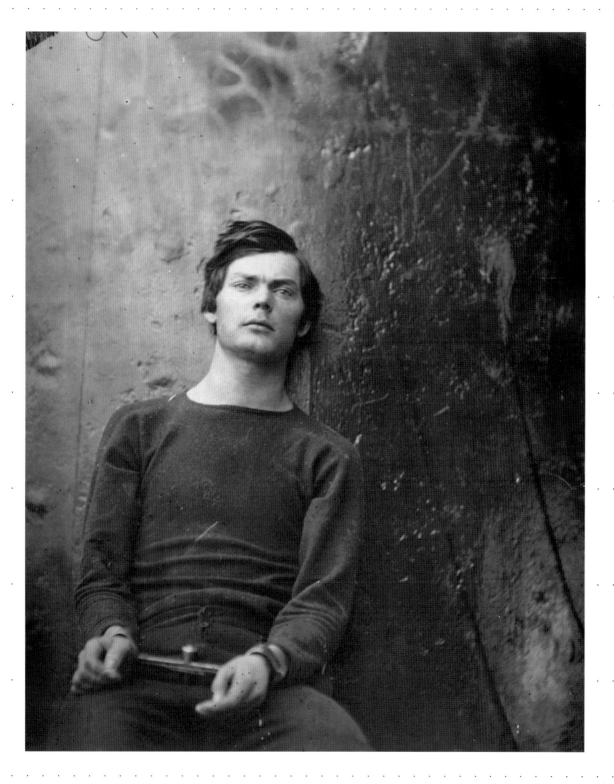

Lewis Payne, Lincoln Conspirator 1865
TITLE DATE

Alexander Gardner
PHOTOGRAPHER

The Library of Congress
COLLECTION

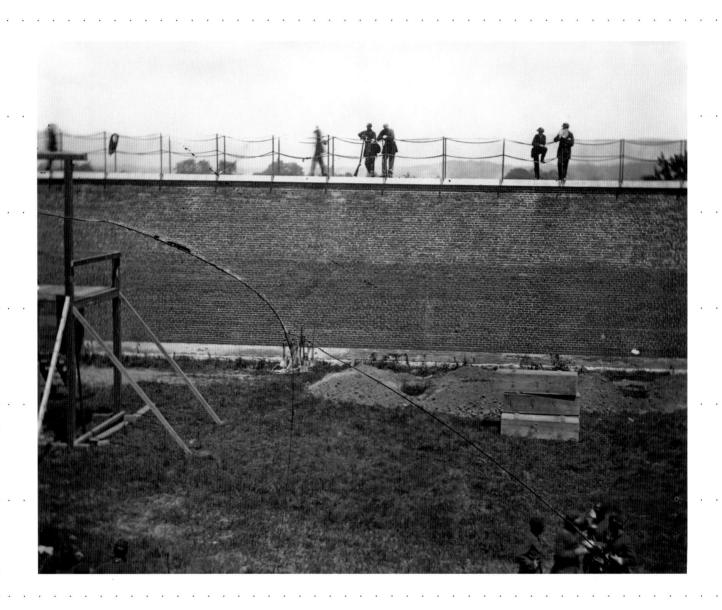

No. 0025

Coffins and Open Graves Ready for Conspirators'
Bodies at Right of Scaffold, Washington, D.C.,
July 7, 1865 1865
TITLE DATE

Alexander Gardner
PHOTOGRAPHER

The Library of Congress
COLLECTION

The Secret Service gave Alexander Gardner carte blanche to
photograph the people and places involved in the events after
Lincoln's assassination. He was the only photographer on hand
to witness the execution of co-conspirators Lewis Powell, Mary
Surratt, David Herold, and George Atzerodt. John Wilkes Booth
was shot while attempting to escape from his barn hideout after
it had been set on fire by Secret Service agents.

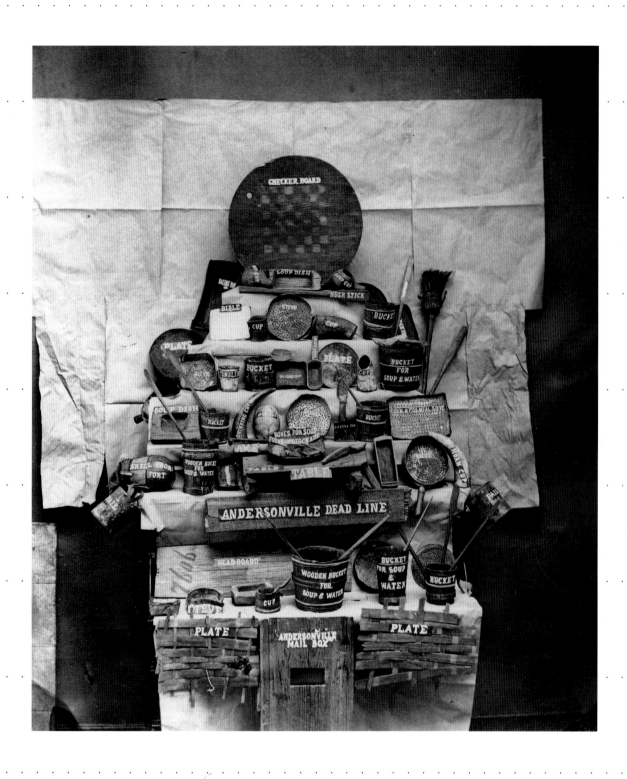

No. 0026

Andersonville Still Life 1866
TITLE DATE

Brady Studio
PHOTOGRAPHER

Gilman Paper Company Collection
COLLECTION

Of the more than 40,000 Union soldiers imprisoned in the Confederate prison at Andersonville, Georgia, 13,000 died of starvation. Souvenirs of the prison were sold to veterans to raise money for the proper burial of the Andersonville dead.

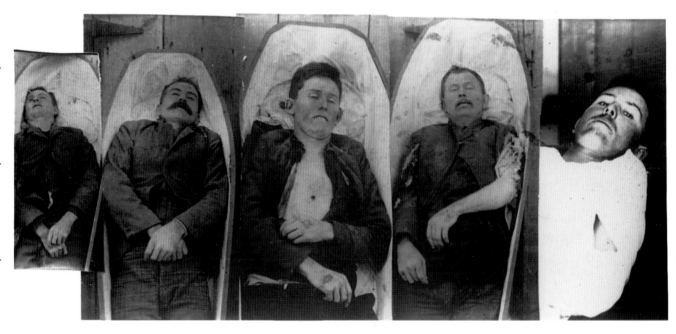

№. 0027

TOP: *Jesse Woodson James* ca. 1870
TITLE DATE

Unknown
PHOTOGRAPHER

National Portrait Gallery, Smithsonian Institution
COLLECTION

№. 0028

BOTTOM: *Dalton Gang after the Coffeyville Bank Robbery*
(from left: Dick Brodwell, Bill Powers, Bob Dalton,
Grat Dalton, and Emmett Dalton) 1892
TITLE DATE

C. G. Glass, Coffeyville, Kansas
PHOTOGRAPHER

Kansas State Historical Society, Topeka, Kansas
COLLECTION

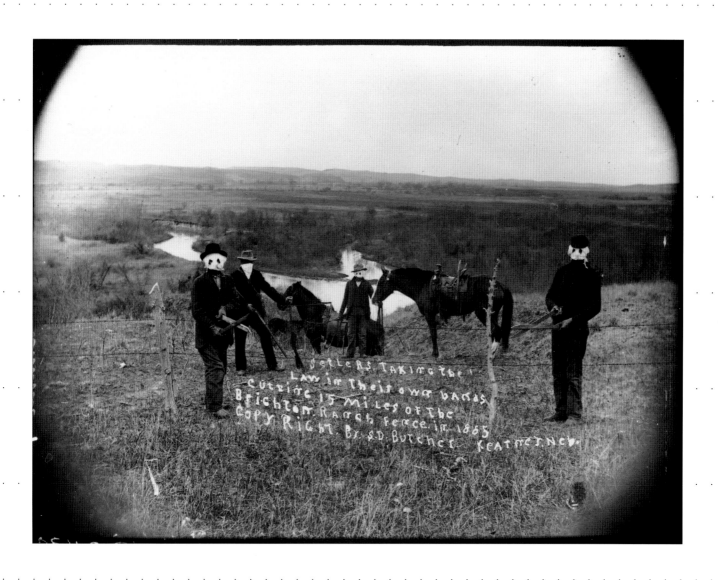

*Settlers Taking the Law into Their
Own Hands Cutting 15 Miles of the
Brighton Ranch Fence in 1885* 1885
TITLE DATE

Solomon D. Butcher
PHOTOGRAPHER

Solomon D. Butcher Collection, Nebraska State Historical Society
COLLECTION

This picture is a reenactment of an incident in which homesteaders
cut every section of a fifteen-mile fence put up to protect the
Brighton Ranch from encroaching settlers. Butcher staged this
photograph to illustrate the tensions between farmers and ranchers
in Custer County, Nebraska.

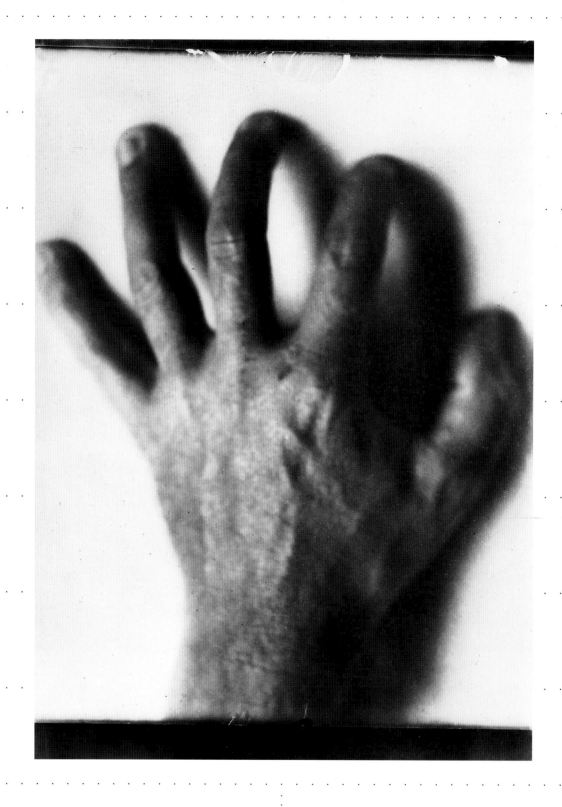

Nᵒ. 0030

Hand of Ching See Foo, the Chinese
Strangler Shot in Frisco in 1893 1893
TITLE DATE

Unknown
PHOTOGRAPHER

Courtesy of Stephen Wirtz Gallery, San Francisco
COLLECTION

№. 0031

Fan-tan Room and Table in
Sing Hing & Co., Ventura, CA　　　　ca. 1902
TITLE　　　　　　　　　　　　　　　　　　DATE

Unknown
PHOTOGRAPHER
National Archives and Records Administration
Pacific Region (San Francisco)
COLLECTION

76 2176
EDDIE HUNT P.L.

DESCRIPTION AND PHOTOS
.....OF.....
San Joaquin County Prisoners.

Name *Eddie Hunt*

Aliases

San Quentin No.

Folsom No.

| Nativity Cal. Los Angeles | Age 13 | Height 4-11 3/4 Complexion medium | Weight 100 Occupation None |
| Eyes Blue | Hair Dk. Brown | | |

Crime *Vagrant*

Date of Crime *Nov. 26-02*

When Arrested " 26 '02

Sentenced to 10 days Co Jail

Sentenced when *Nov. 26 - 1902*

Property Stolen

Who from

Remarks
2 Vac. left upper arm
Scar under left Eye
" End First finger left hand
Small . base left thumb

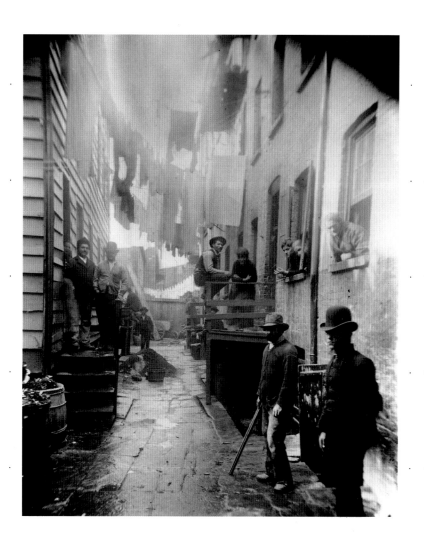

№. 0033

Bandit's Roost, 39 1/2 Mulberry Street ca. 1890
TITLE DATE

Jacob Riis
PHOTOGRAPHER

Jacob A. Riis Collection, #101, Museum of the City of New York
COLLECTION

Jacob Riis, a newspaper reporter, used photographs to expose
the conditions that immigrants to New York City faced. He was
convinced that environment rather than biological predisposition
was a cause of crime, and used photographs—either taken by himself
or by others—in his crusade to eradicate these conditions.

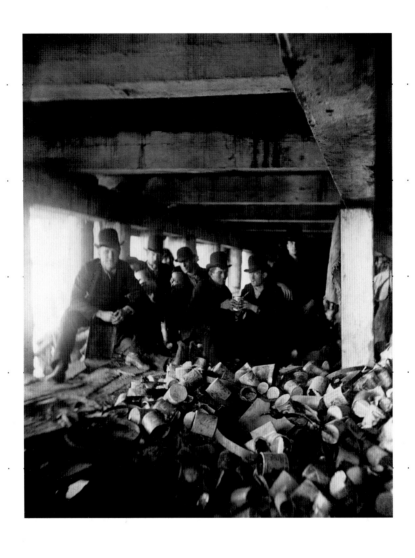

The Short Tail Gang, Corlear's Hook ca. 1889
TITLE DATE

Jacob Riis
PHOTOGRAPHER

Jacob A. Riis Collection, # 141, Museum of the City of New York
COLLECTION

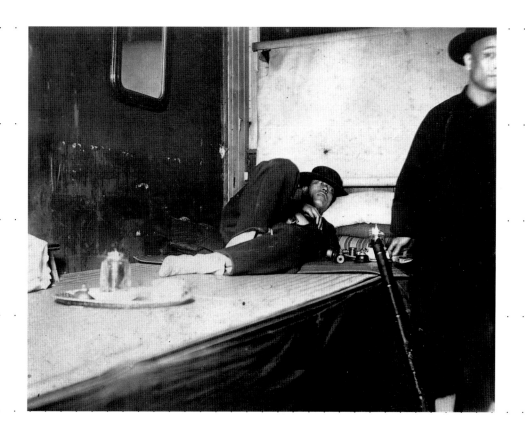

Chinatown Opium Joint ca. 1890
TITLE DATE

Jacob Riis (attributed to Richard Hoe Lawrence)
PHOTOGRAPHER

Jacob A. Riis Collection, # M, Museum of the City of New York
COLLECTION

Inspector Thomas Byrnes was chief of the New York Detective Bureau in the 1880s. In 1886, with the view that it would help the general public in the prevention and detection of crime (as well as advertise the daring exploits and superior intelligence of the Police Department), he compiled this book containing photographs and biographical descriptions and records of 204 celebrated criminals as well as essays on various criminal types and their methods.

№. 0036

№. 0037

TOP: Plates 94—96 from the book *Professional Criminals of America* by Thomas Byrnes 1886
TITLE DATE

Unknown
PHOTOGRAPHER

Stanley B. Burns, M.D., and the Burns Archive
COLLECTION

BOTTOM: Untitled ca. 1890 / print ca. 19
TITLE DATE

Jacob Riis
PHOTOGRAPHER

Courtesy of Howard Greenberg Gallery
COLLECTION

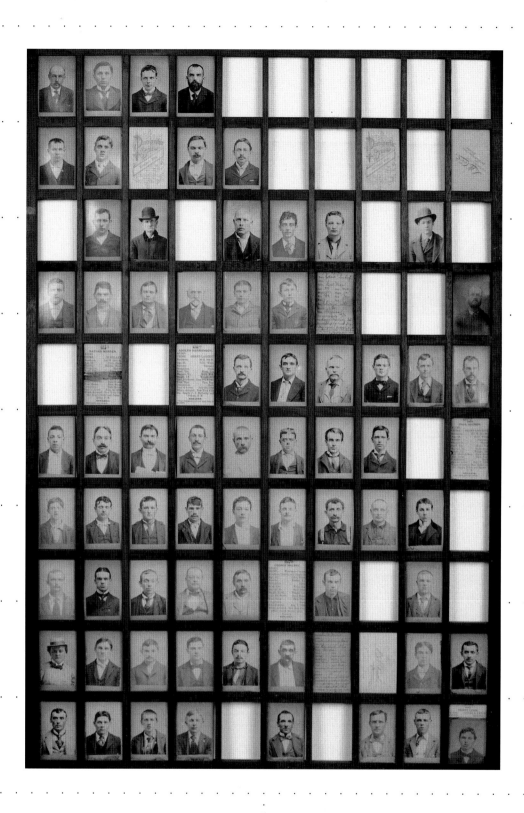

№. 0038

Untitled ca. 1890
TITLE DATE

Unknown
PHOTOGRAPHER

Patterson Smith, Antiquarian Bookseller
COLLECTION

This is a frame from an Adams Photographic Cabinet (patented in 1876), which consisted of eight to ten frames hinged within a wooden cabinet. Each side of the frame held one hundred carte-de-visite-sized portraits of criminals, on the back of which were printed brief information (name, age, occupation, date of arrest, etc.). Numbers stamped on the frame below each portrait provided keys for cross-referencing.

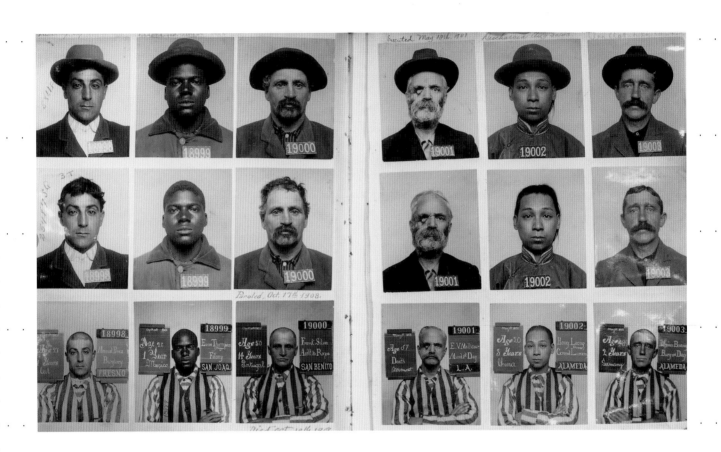

Untitled 1873–1917
TITLE DATE

Department of Corrections, San Quentin Prison
PHOTOGRAPHER

California State Archives
COLLECTION

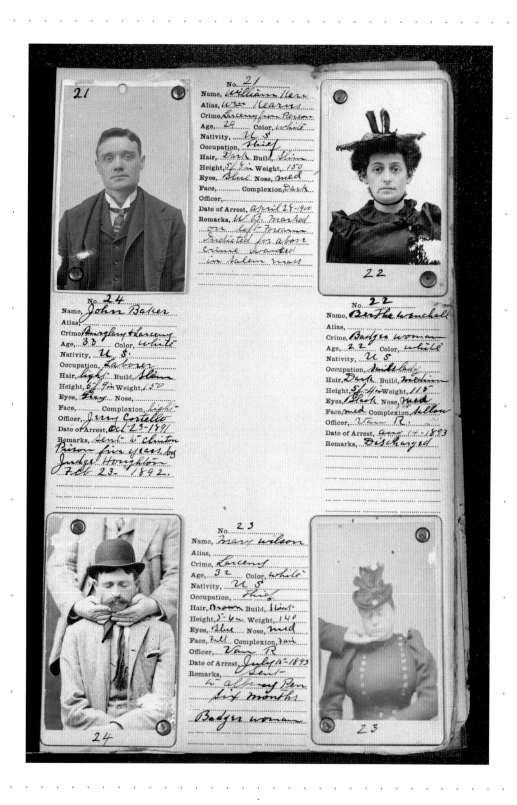

Untitled
TITLE

ca. 1900
DATE

Unknown
PHOTOGRAPHER

Private Collection
COLLECTION

Shown here are four thieves, two of whom are held in position for the photographer. The two women are described as "badger women." In the badger "game," a woman inveigled a man into her hotel room, after which her male accomplice, pretending to be her husband, burst in. Feigning outrage, he would extort money from the compromised victim upon pain of exposing him to his family or to the police.

Card No. 16.

$100 REWARD

DENNY HAZEL, convicted of murder in the first degree and who was being held in the Siskiyou County Jail, pending a hearing on motion for a new trial, escaped Monday, October 26, 1908, at a few minutes to six p. m. by jumping behind the jailer while he was locking up for the night, and rushing through the door, which he closed and locked the jailer in and escaped.

DESCRIPTION

The above is a very good picture of the man, with the exception that when he escaped, he had a six weeks growth of beard all over his face.

NAME, Denny Hazel; AGE, 42; HEIGHT, 5 ft 6 inches; WEIGHT, about 145 pounds; CLOTHES, blue overalls, blue flannel shirt, no coat nor hat when he left the jail; COMPLEXION, light, he had no color in his face caused from long confinement in jail; BEARD, has a heavy growth of beard all over his face, had not shaved for six weeks, beard is very dark brown; RE= MARKS, he is perfectly bald, just a rim of hair around his head about where his hat comes, which is dark brown. He is a River Log Driver and may be found in or around logging camps.

He took no firearms with him when he escaped, so unless given firearms by some one on the outside, he is unarmed.

I Want this man very bad and officers are notified to keep a close watch and if caught, wire me, at my expense, and I will immediately come for him, and cheerfully pay the above reward.

CHAS. B. HOWARD,
Sheriff Siskiyou Co., Cal.

Yreka, October 29, 1908.

No. 0041

$100 REWARD. . . 1908
TITLE DATE

Unknown
PHOTOGRAPHER

Peter E. Palmquist
COLLECTION

Pete Bergest

BURGLARY 1-15

NATIVITY	**EYES**
AGE	**COMP.**
HEIGHT	**HAIR**
WT.	**OCCUP.**
DATE ARREST	**BY**

No. 0042

Untitled ca. 1930
TITLE DATE

Unknown
PHOTOGRAPHER

San Francisco Museum of Modern Art. Accessions Committee Fund
COLLECTION

No. 0043

*Three French Criminals, Accused
of Passport Forgery* 1932
TITLE DATE

Unknown
PHOTOGRAPHER

San Francisco Museum of Modern Art. Members of Foto Forum, 96.511
COLLECTION

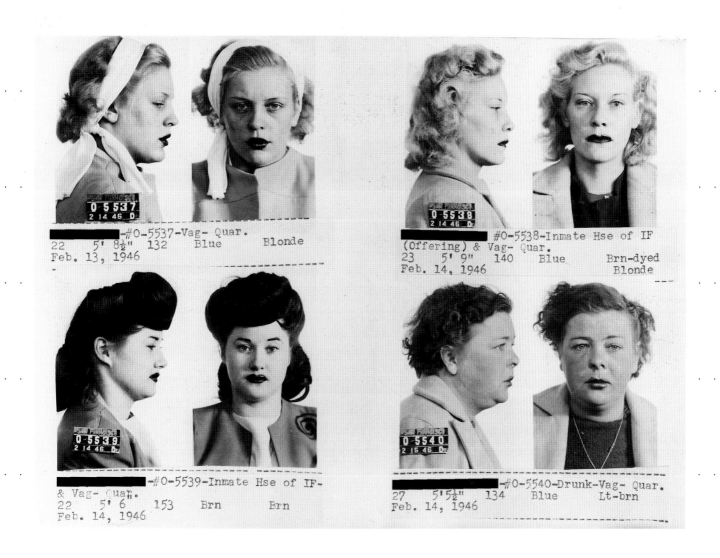

#O-5537-Vag- Quar.
22 5' 8½" 132 Blue Blonde
Feb. 13, 1946

#O-5538-Inmate Hse of IF
(Offering) & Vag- Quar.
23 5' 9" 140 Blue Brn-dyed
Feb. 14, 1946 Blonde

#O-5539-Inmate Hse of IF-
& Vag- Quar.
22 5' 6" 153 Brn Brn
Feb. 14, 1946

#O-5540-Drunk-Vag- Quar.
27 5'5½" 134 Blue Lt-brn
Feb. 14, 1946

№. 0044

Untitled San Francisco Police Department
album of prostitutes and vagrant women 1945
TITLE DATE

Unknown
PHOTOGRAPHER

Private Collection
COLLECTION

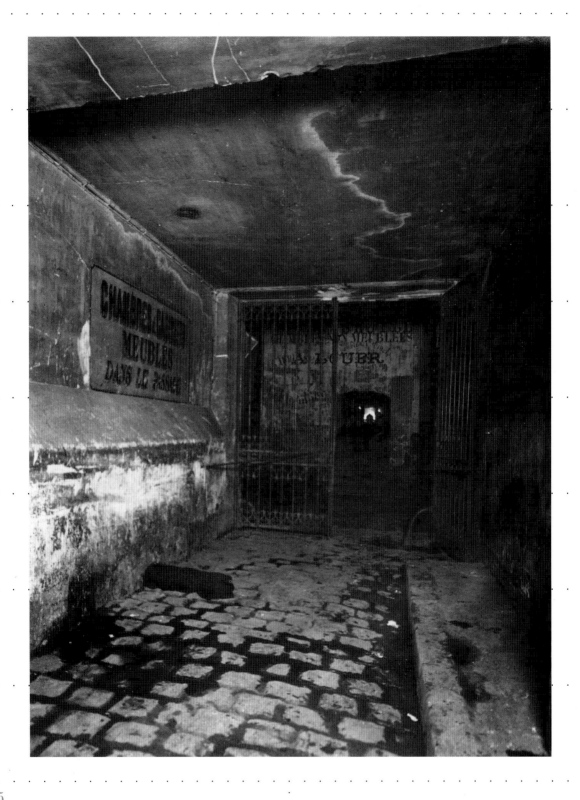

Assassinat du jeune Grégoire Pierre dit le
"Petit Pierre," le 14 Décembre, 1896:
"Cité Vanneau—Endroit où l'enfant a été trouvé" 1896
TITLE DATE

Unknown, possibly Alphonse Bertillon
PHOTOGRAPHER

Gérard Lévy, Paris
COLLECTION

(Assassination of Young Grégoire Pierre, called
"Little Pierre," December 14, 1896: "Vanneau—
Place where the child was found")

Assassinat de Botelin Valentine, 14.9.04 1904
TITLE DATE

Unknown
PHOTOGRAPHER

Archives Historiques et Musée de la Préfecture de Police, Paris
COLLECTION

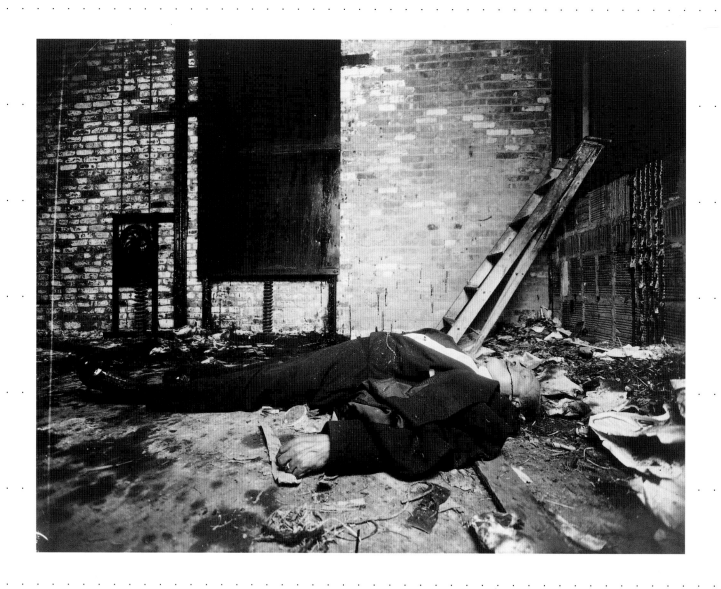

№. 0047

"...found in bottom of freight...shaft at Marmon
Auto Co....Employed as night watchman...145th St...
near 8th Avenue..."　　　　　　　　　　　　ca. 1920
TITLE　　　　　　　　　　　　　　　　　　　　　　　DATE

Unknown
PHOTOGRAPHER

Glenn Spellman Fine Art Photography, New York
COLLECTION

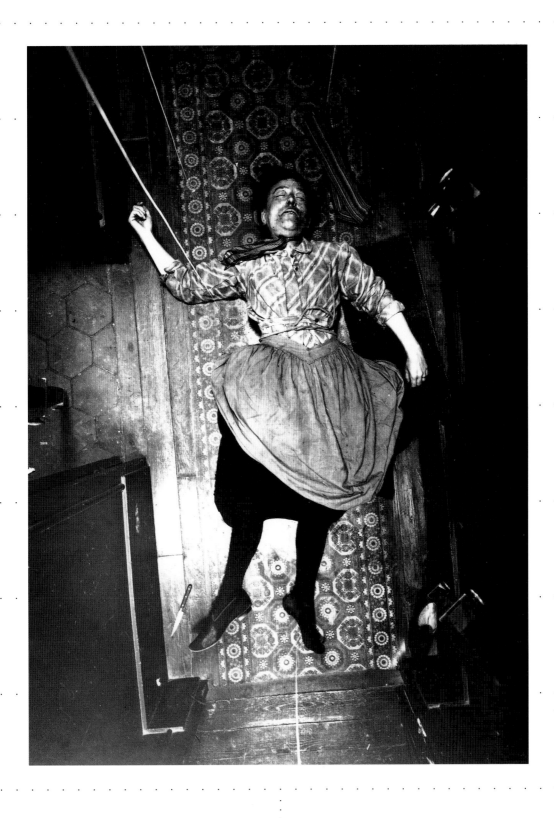

№. 0048

Affaire de Puteaux (Seine),
Assassinat de Mme. Langlois n.d.
TITLE DATE

Unknown
PHOTOGRAPHER

Archives Historiques et Musée de la Préfecture de Police, Paris
COLLECTION

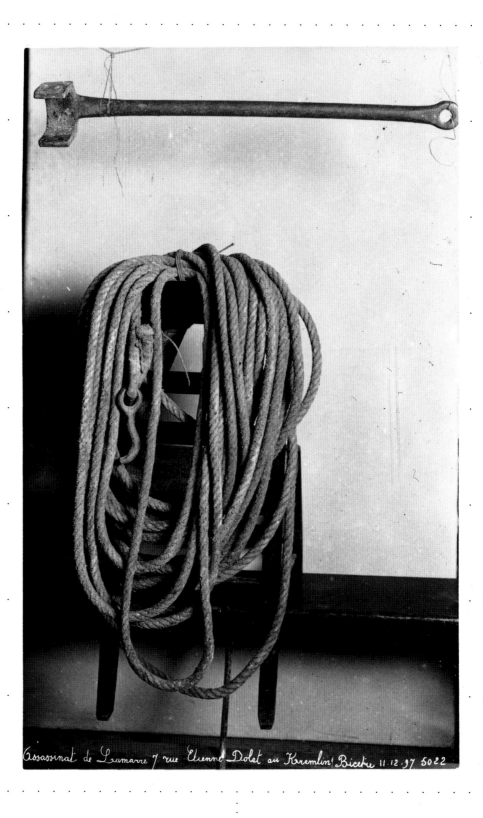

Assassinat de Lamarre 7 rue Etienne Dolet au Kremlin Bicêtre 11.12.97 5022

№. 0049

Assassinat de Lamarre, 7, rue Etienne Dolet
au Kremlin Bicêtre, 11.12.97 1897
TITLE DATE

Unknown
PHOTOGRAPHER

Archives Historiques et Musée de la Préfecture de Police, Paris
COLLECTION

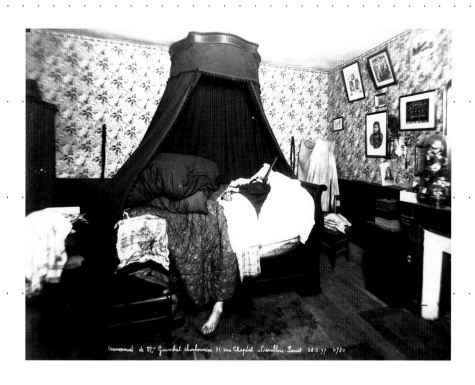

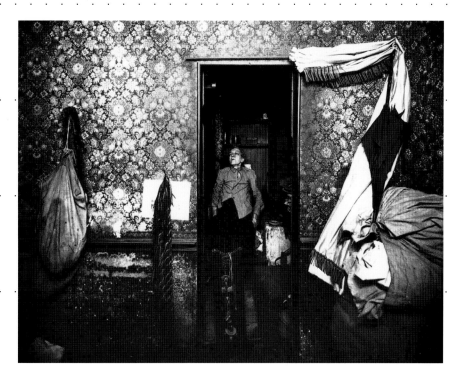

№. 0050

TOP: *Assassinat de M. Grimbal, charbonnier,*
31 rue Chaptal, Levallois-Perret, 28.5.97 1897
TITLE DATE

Unknown
PHOTOGRAPHER

Archives Historiques et Musée de la Préfecture de Police, Paris
COLLECTION

№. 0051

BOTTOM: *Affaire de la rue Erard No.8,*
Assassinat de Mme. Veuve Noyer n.d.
TITLE DATE

Unknown
PHOTOGRAPHER

Archives Historiques et Musée de la Préfecture de Police, Paris
COLLECTION

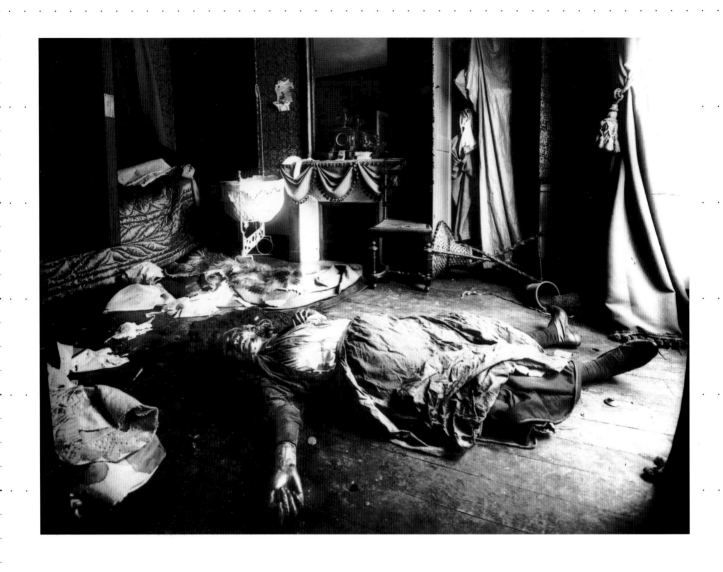

No. 0052

Crime de la rue Bouchardon (Madame Daly) n.d.
TITLE DATE

Unknown
PHOTOGRAPHER

Archives Historiques et Musée de la Préfecture de Police, Paris
COLLECTION

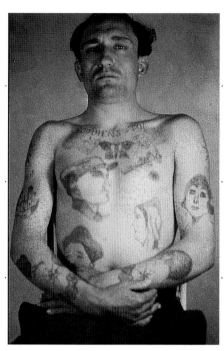

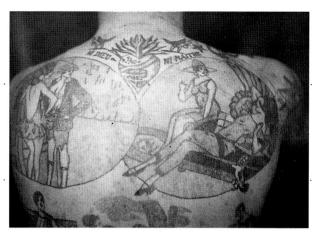

(54) *Prison de Saint Pothin, 9/1/34: Dos tatoué de scène de bordel et la devise des anarchistes: "Ni Dieu ni Maître"*

(Saint Pothin Prison, 1/9/34: Back tattooed with a brothel scene and the motto of anarchists: "Neither God nor Master")

(53) *Hôpital de la Grange Blanche, 14/9/34: Tatouage d'un ancien du Bataillon disciplinaire d'Afrique (Maroc): "Souviens toi"*

(Grange Blanche Hospital, 9/14/34: Tattoo of an elder from the disciplinary batallion of Africa (Morocco): "Remember")

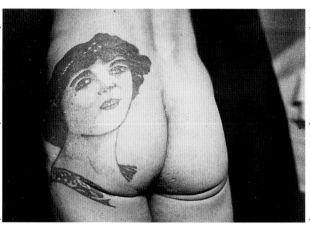

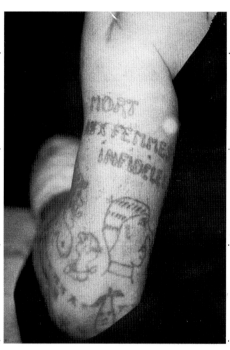

(55) *Prison de Saint Pothin, 19/1/34: Portrait*

(56) *Prison de Saint Pothin, 20/1/34: Bras d'un souteneur: "Mort aux femmes infidèles"*

(Saint Pothin Prison, 1/20/34: Arm of a pimp: "Death to unfaithful women")

Nos. 0053, 0054, 0055, 0056

see above 1934
TITLE DATE

Dr. Petouraud
PHOTOGRAPHER

Gérard Lévy, Paris
COLLECTION

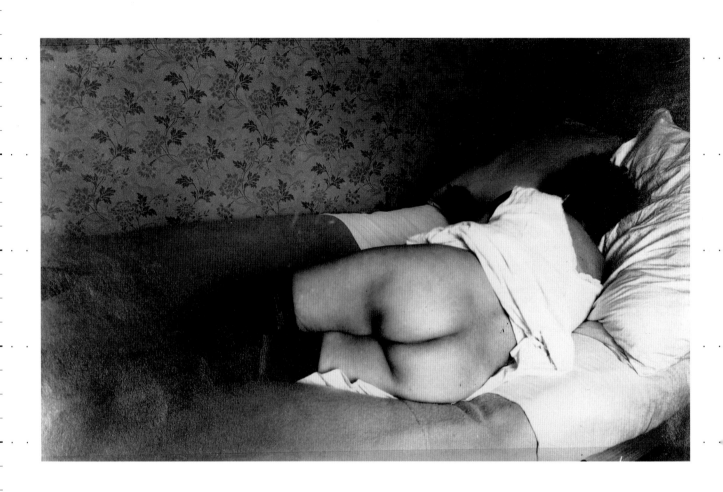

Untitled ca. 1925
TITLE DATE

Eugène Atget
PHOTOGRAPHER

The New York Public Library
COLLECTION

These Atget photographs are among the thirty-seven (mostly pornographic) extra illustrations pasted by Pierre Mac Orlan into his copy of Cesare Lombroso's book *La Femme criminelle et la prostituée* (The Criminal Woman and the Prostitute). It is believed that Atget's pictures were taken as part of a commission by the painter André Dignmont to document prostitution.

Versailles, femme et soldat, maison close. Mai 1921
(Versailles, Woman and Soldier, Brothel. May 1921) 1921
TITLE DATE

Eugène Atget
PHOTOGRAPHER

The New York Public Library
COLLECTION

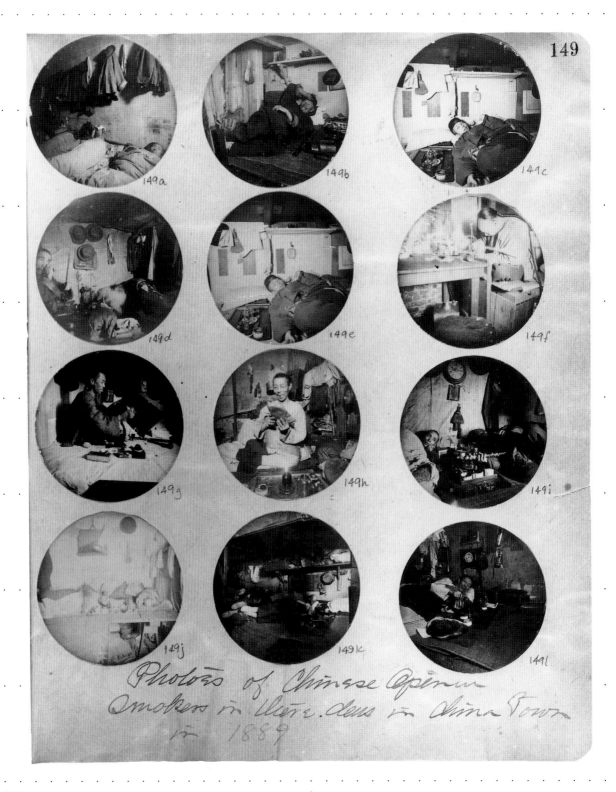

149

Photos of Chinese Opium Smokers in there dens in China Town in 1889

Photos of Chinese Opium Smokers in There
[sic] *Dens in China Town in 1889*, page
from *The Jesse Brown Cook Scrapbook ...* ca. 1910–35
TITLE DATE

Unknown
PHOTOGRAPHER

The Bancroft Library, University of California, Berkeley
COLLECTION

Jesse Brown Cook began his career with the San Francisco Police
Department in 1889, eventually working his way up to police chief.
After retiring as chief in 1910, he was appointed to five terms
as police commissioner, his last ending six years before his death
in 1938. While commissioner he compiled thirty-five scrapbooks of
clippings, snapshots, and police photographs of San Francisco
criminals, crimes, and history.

March 21/22: Ernest Long Chief Engineer on the Steamship
Rose City Was Arrested for Impersonating a Woman,
page from *The Jesse Brown Cook Scrapbook . . .* ca. 1910—35
TITLE DATE

Unknown
PHOTOGRAPHER

The Bancroft Library, University of California, Berkeley
COLLECTION

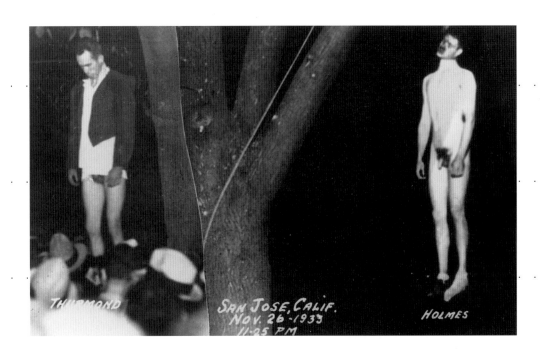

No. 0061

Lynching of Thurmond and Holmes, San Jose,
Calif., Nov. 26, 1933, 11:25 p.m. 1933
TITLE DATE

Unknown
PHOTOGRAPHER

California Historical Society, San Francisco
COLLECTION

In 1933, a mob in San Jose broke into the jail house,
forcibly removed two men arrested for kidnapping the son
of a local department store owner, beat them, and then
hanged them. It was the last lynching in California.

Same Parade the Hole in the wall the Bomb made

No. 0062

Same Parade, the Hole in the Wall
the Bomb Made, detail of page from
The Jesse Brown Cook Scrapbook . . . ca. 1910—35
TITLE DATE

Unknown
PHOTOGRAPHER

The Bancroft Library, University of California, Berkeley
COLLECTION

On July 22, 1916, a bomb exploded during the wartime
Preparedness Day parade in San Francisco, killing ten
people. The anti-union feeling of the time led to the
framing of Thomas Mooney, a prominent labor leader, for
the crime. After years of protest and evidence exposing
the perjury of key prosecution witnesses, he was finally
released from prison in 1939.

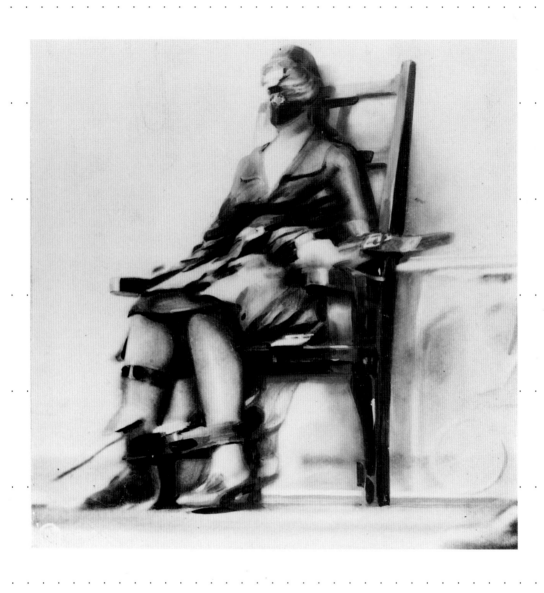

The Electrocution of Ruth Snyder 1928
TITLE DATE

Tom Howard
PHOTOGRAPHER

San Francisco Museum of Modern Art. Accessions Committee Fund, 96.428
COLLECTION

Convicted of killing her husband, Ruth Snyder was the first woman to be electrocuted in the United States. The New York *Daily News* hired *Chicago Tribune* photographer Tom Howard to smuggle his camera into the execution chamber. The camera was strapped to his leg and the resulting image is blurred not because Howard moved but because he made three exposures on the single glass negative: when the current was turned on, off, and on again.

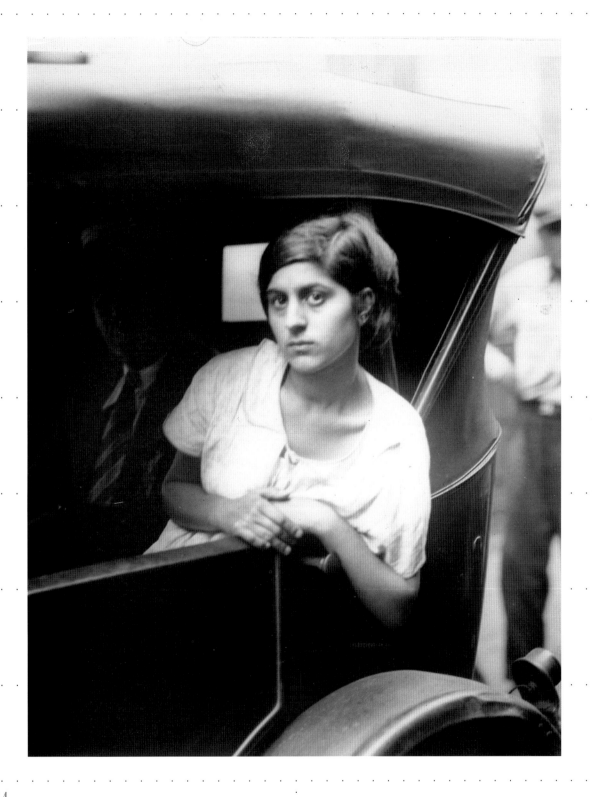

Marie Cirenchia, Confessed Murderess 1920
TITLE DATE

Unknown
PHOTOGRAPHER

Thomas Walther Collection, New York
COLLECTION

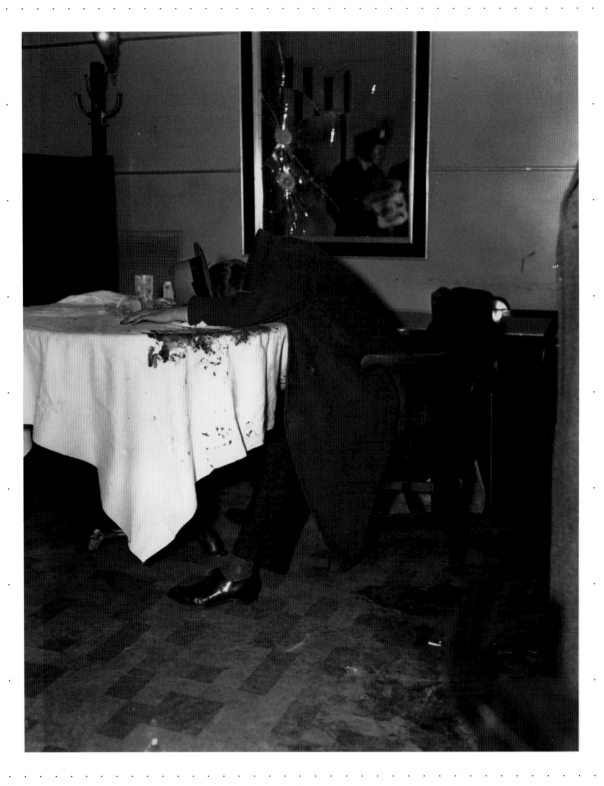

№. 0065

Scene of Dutch Schultz Shooting at the
Palace Bar and Grill, Newark, New Jersey 1935
TITLE DATE

International News Photos
PHOTOGRAPHER

UPI/Corbis-Bettmann
COLLECTION

In 1935 Lucky Luciano ordered a hit on fellow gangster Arthur
"Dutch Schultz" Flegenheimer and his "aides" after Schultz
announced his intention to kill the anti-mob prosecutor Thomas E.
Dewey. Luciano feared this murder would draw unwanted attention t
the racketeers, so he put out an order to silence Schultz. Along
with three other gangsters, Schultz was gunned down in a Newark,
New Jersey, restaurant.

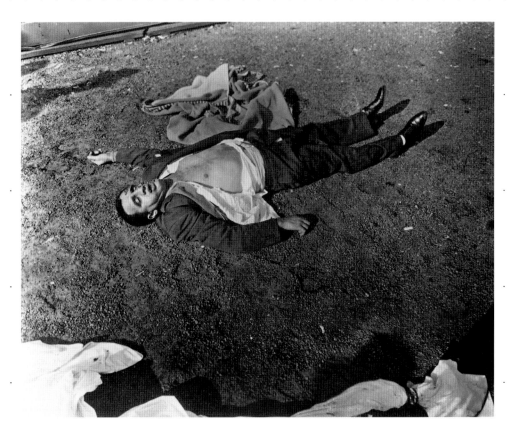

Abe "Kid Twist" Reles was a hit man for the
Brooklyn crime syndicate Murder Inc. who decided
to testify against the group in 1941. Before the
trial, he was pushed from his window at the Half
Moon Hotel where he was under police guard. The
rolled up sheet at the bottom of the photograph
is part of the attempt to make his death appear
to be a botched escape from the hotel.

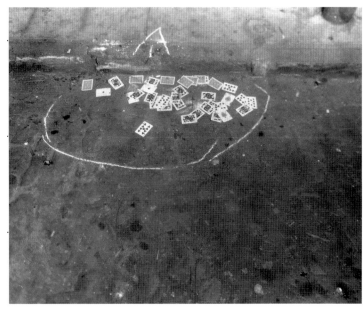

№. 0066

TOP: Untitled (Abe Reles, deceased,
Half Moon Hotel, Coney Island, New York) 1941
TITLE DATE

Unknown
PHOTOGRAPHER

New York City Municipal Archives
COLLECTION

№. 0067

BOTTOM: Untitled ca. 1930s
TITLE DATE

Unknown
PHOTOGRAPHER

New York City Municipal Archives
COLLECTION

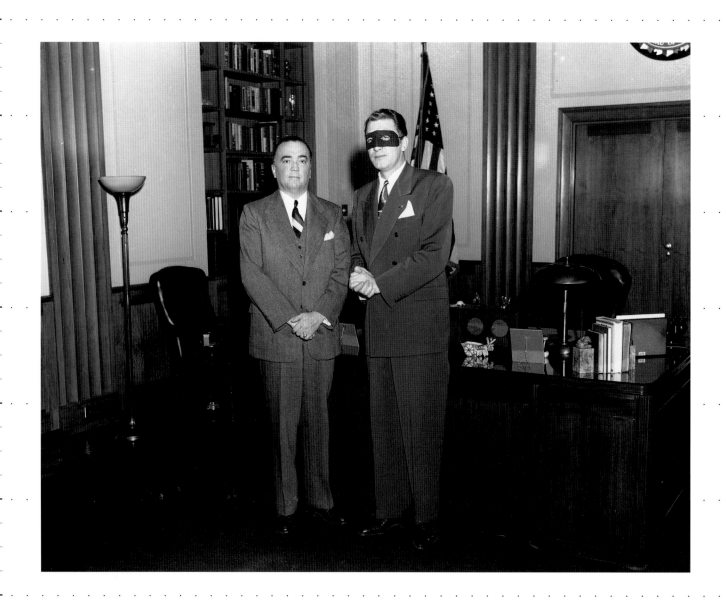

Hoover and Clayton Moore (The Lone Ranger) n.d.
TITLE DATE

Unknown
PHOTOGRAPHER

Courtesy FBI
COLLECTION

George R. "Machine Gun" Kelly n.d.
TITLE DATE

Unknown
PHOTOGRAPHER

Courtesy FBI
COLLECTION

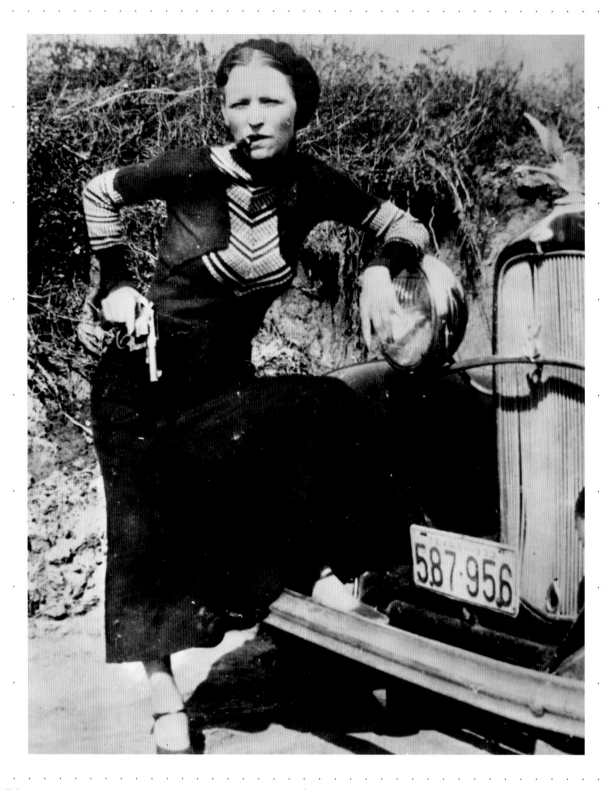

Bonnie Parker, the Gun Moll of the 1930s n.d.
TITLE DATE

Unknown
PHOTOGRAPHER

Stanley B. Burns, M.D., and the Burns Archive
COLLECTION

This image is one of six found by police at the site of a shootout in Missouri. Probably taken by each other, the pictures show Bonnie Parker and her partner, Clyde Barrow, in front of the car where they met their death soon after.

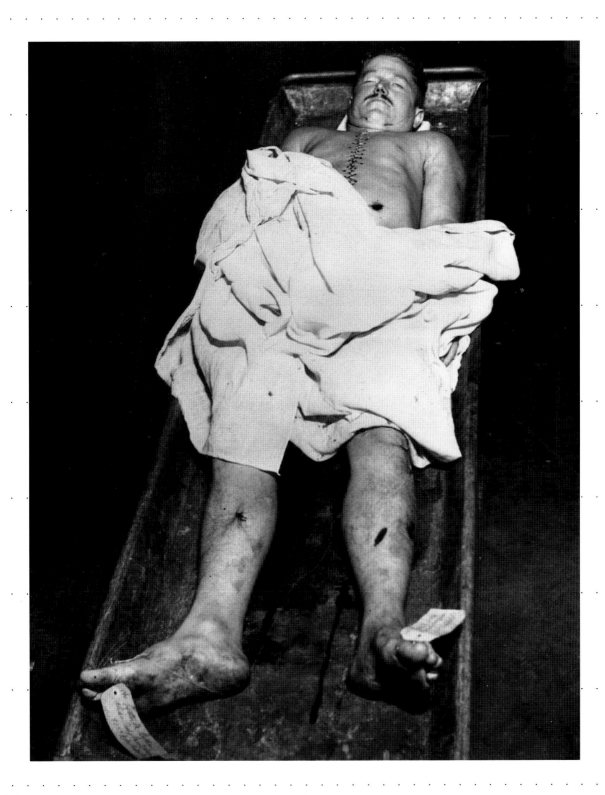

George "Baby Face" Nelson 1934
TITLE DATE

International News Photos
PHOTOGRAPHER

Stanley B. Burns, M.D., and the Burns Archive
COLLECTION

The original caption, dated 12/1/34, reads "Chicago, Ill.: The remains of the late "Baby Face" Nelson pictured in the Cook County Morgue after the Coroner's post-mortem for the inquest in which a verdict of "justifiable homicide" was returned. The hoodlum's body is pictured lying on the same slab where the body of his chief, the late John Dillinger, lay after Federal Agents' guns had done for him."

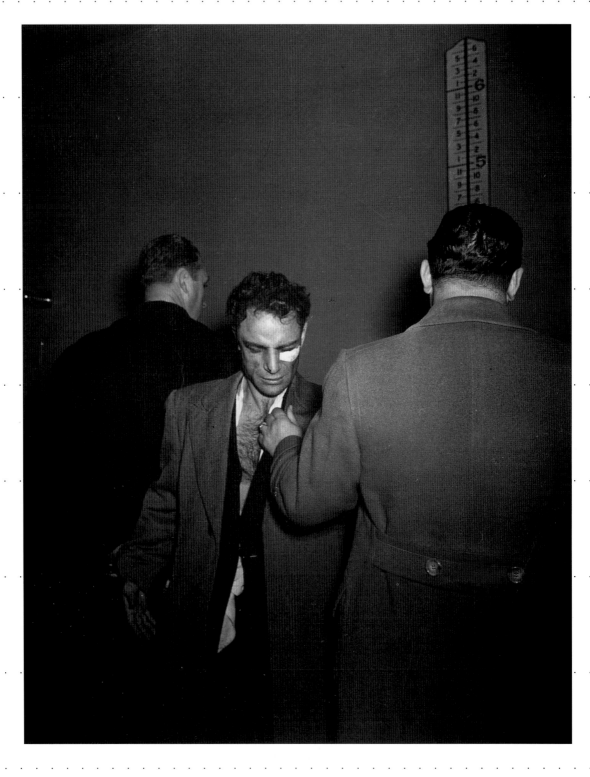

№. 0072

Booked on Suspicion of Killing a Policeman 1939
TITLE DATE

Weegee (Arthur Fellig)
PHOTOGRAPHER

San Francisco Museum of Modern Art, 78.53
COLLECTION

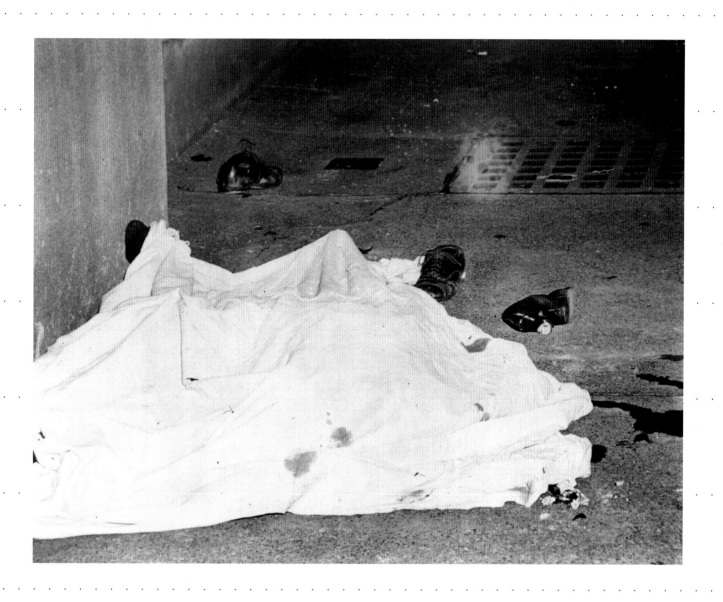

Untitled ca. 1940s
TITLE DATE

Weegee (Arthur Fellig)
PHOTOGRAPHER

Museum of the City of New York, Museum purchase
COLLECTION

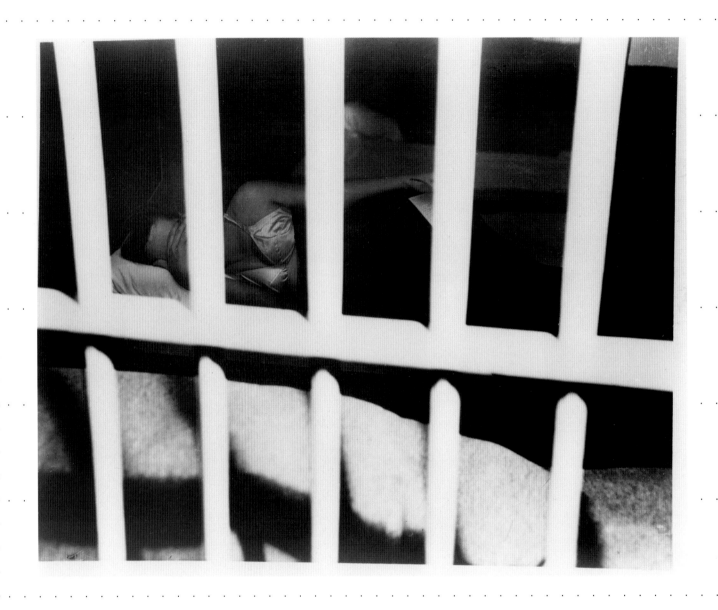

No. 0074

Untitled ca. 1940s
TITLE DATE

Weegee (Arthur Fellig)
PHOTOGRAPHER

Museum of the City of New York, Museum purchase
COLLECTION

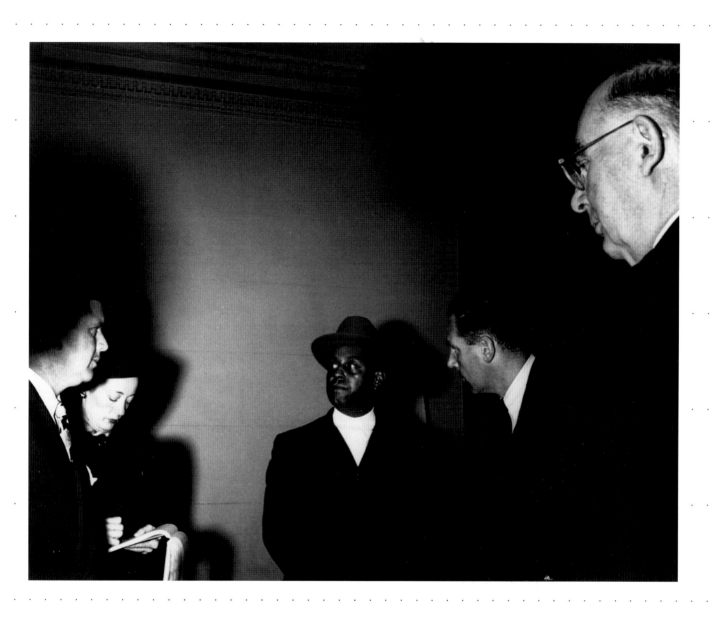

№. 0075

The Killer 1948
ITLE DATE

John Gutmann
PHOTOGRAPHER

Courtesy of the artist and Fraenkel Gallery, San Francisco
COLLECTION

While covering a story on the San Francisco police for the
Saturday Evening Post, John Gutmann saw this man in an
interrogation room with members of the homicide squad (the
woman is a stenographer). He was confessing to murdering
a fellow gambler in an argument over one dollar.

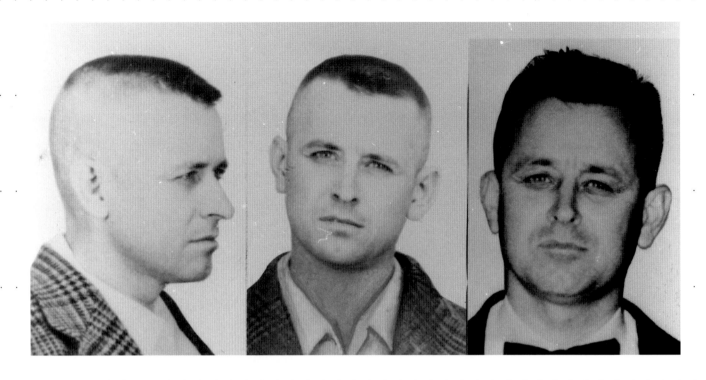

№ 0076

№ 0077

TOP: *James Earl Ray* n.d.
TITLE DATE

Unknown
PHOTOGRAPHER

Courtesy FBI
COLLECTION

BOTTOM: *TNT Demolition Block Showing*
Hole to Acommodate a Detonator n.d.
TITLE DATE

Unknown
PHOTOGRAPHER

Courtesy FBI
COLLECTION

№. 0078

Kurt Frederick Ludwig 1940
TITLE DATE

Unknown
PHOTOGRAPHER

Courtesy FBI
COLLECTION

Kurt Ludwig was an American-born German spy based on the East Coast in the early years of World War II. Working under FBI surveillance for at least a year, he was arrested in 1941 during a cross-country trip to survey military installations.

5049 EF(N) 14. MAY 2. 44. 22·00. F 12" 1500' SECRET D-2

№. 0079

Untitled 1944
TITLE DATE

Harold E. Edgerton
PHOTOGRAPHER

Arlette and Gus Kayafas
COLLECTION

Known for his development of highspeed stop-motion photography,
MIT professor Harold Edgerton was asked during World War II to
develop a flash system large enough to be used in nighttime
aerial surveillance photography. After testing the system,
Edgerton made a series of photographs over locations in Normandy
with suspected German troop movements. These images were used
to help determine the ultimate location of the D-Day landing.

5054

EF(N)14.MAY2.44.2200.F12"1500' SECRET D-2

Untitled	1944
TITLE	DATE

Harold E. Edgerton
PHOTOGRAPHER

Arlette and Gus Kayafas
COLLECTION

No. 0081

Untitled, from the project *Evidence* 1977
TITLE DATE

Mike Mandel and Larry Sultan
PHOTOGRAPHER

San Francisco Museum of Modern Art. Purchased through a gift
of Mary and Thomas Field, Accessions Committee Fund, 93.43.19
COLLECTION

Artists Larry Sultan and Mike Mandel examined more than
fifty civic and corporate photographic archives, amassing
a collection of mysterious pictures that they published
in a book titled *Evidence*.

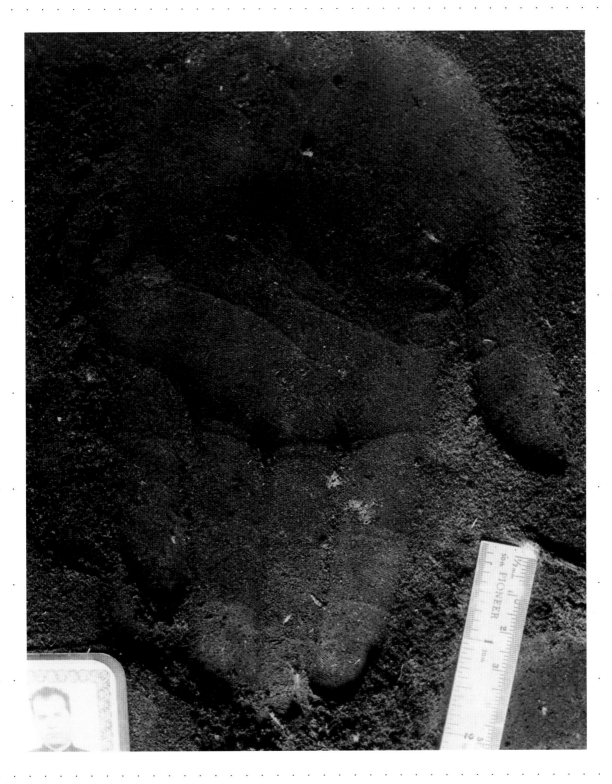

№. 0082

Untitled, from the project *Evidence* 1977
TITLE DATE

Mike Mandel and Larry Sultan
PHOTOGRAPHER

San Francisco Museum of Modern Art. Purchased through a gift of
Mary and Thomas Field, Accessions Committee Fund, 93.43.22
COLLECTION

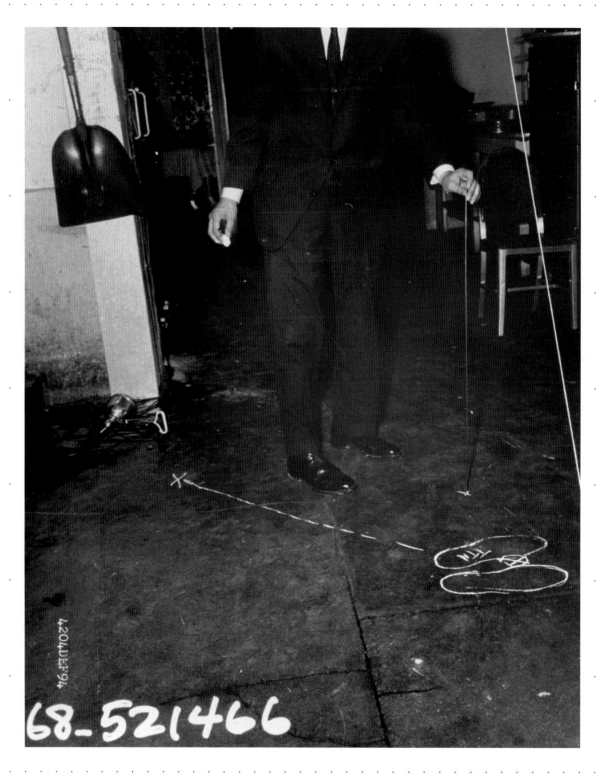

68-521466

No. 0083

Reenactment 1968
TITLE DATE

Unknown
PHOTOGRAPHER

California State Archives
COLLECTION

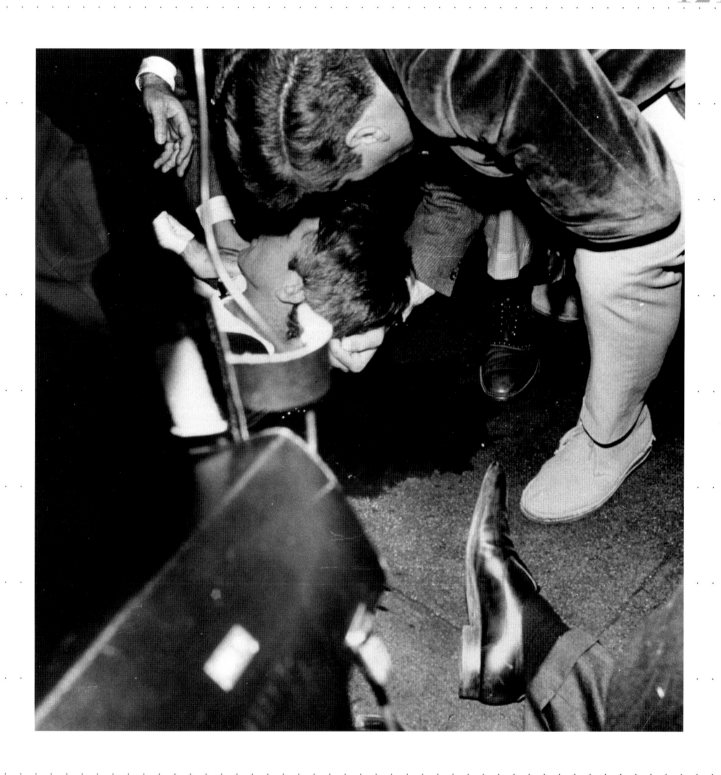

№. 0084

Aftermath 1968
TITLE DATE

Harold Burba, for the Los Angeles Fire Department
PHOTOGRAPHER

California State Archives
COLLECTION

The original caption reads "In July 1966, three men held up a bank in a small Ohio town and escaped with over $26,000. During the robbery, one of the robbers activated a sequence camera which caused a clicking sound on a radio playing in the bank, alerting the robbers that photographs were being taken. One robber came behind the teller's cage, stood on a stool and hammered the camera with a pistol; however, a photograph was obtained which resulted in his identification."

№ 0085

TOP: Untitled 1966
TITLE DATE

Unknown
PHOTOGRAPHER

National Archives, Washington, D.C.
COLLECTION

№ 0086

BOTTOM: Untitled photo of
a demonstration at the
Stanford Research Institute 1969
TITLE DATE

Unknown
PHOTOGRAPHER

Andrew Moss
COLLECTION

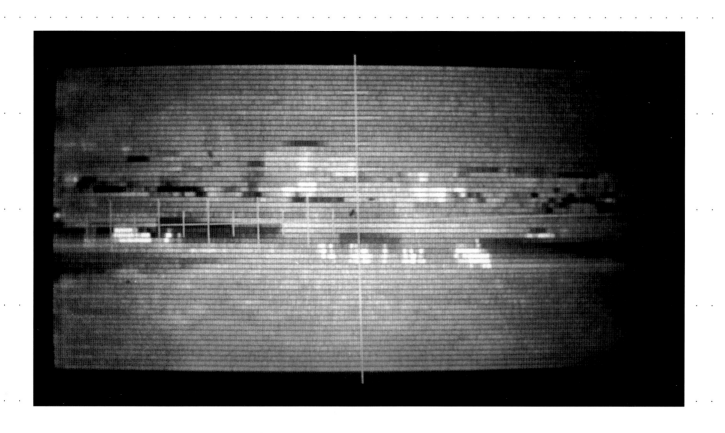

№. 0087

*Ghostly view through night-vision infrared scope
shows nearly a dozen illegals caught between
horseback-mounted and truck units of border police.* 1995
TITLE DATE

Dave Gatley
PHOTOGRAPHER

San Francisco Museum of Modern Art. Accessions Committee Fund
COLLECTION

In Southern California, along the U.S.—Mexico border,
pairs of border patrol agents position themselves on
hilltop promontories and survey the surrounding areas
using infrared scopes. While covering a story for the
Los Angeles Times in 1995, Dave Gatley positioned his
camera directly in a scope and photographed confrontations
between U.S. border patrols and illegal immigrants.

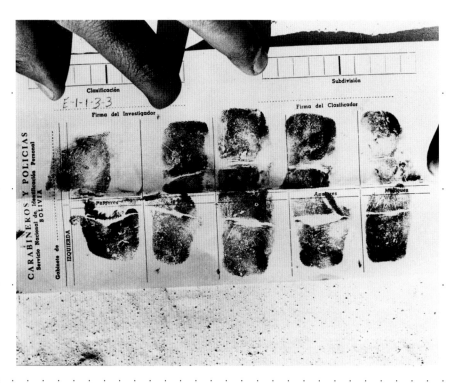

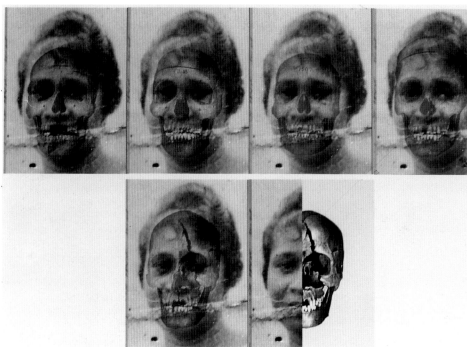

This computer-generated composite photograph shows the picture of a missing woman superimposed on five different skulls. The result of this process was a close match that indicated the probability that one of these unidentified skulls belonged to the missing woman.

№. 0088

№. 0089

TOP: *Fingerprints of Che Guevara* 1967
TITLE DATE

United Press International
PHOTOGRAPHER

San Francisco Museum of Modern Art, 96.334
COLLECTION

BOTTOM: Untitled 1994
TITLE DATE

Gene O'Donnell, FBI
PHOTOGRAPHER

Courtesy of the Investigative and Prosecutive Graphic Design Unit,
COLLECTION

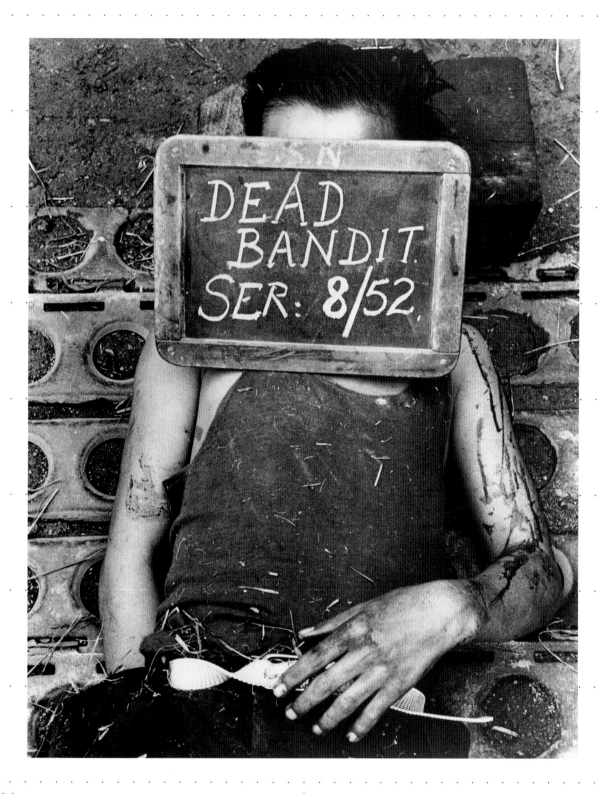

№. 0090

Dead Bandit 1954
TITLE DATE

Howard J. Sochurek, *Life* magazine
PHOTOGRAPHER

San Francisco Museum of Modern Art. Accessions Committee Fund. 96.320
Courtesy of Time Inc.
COLLECTION

Chin Chai was a sixteen-year-old Chinese communist,
a political "bandit" who had been twice arrested in
the British colony of Malaya before being shot dead
by the police. He was photographed lying in the
police station courtyard prior to his autopsy and
burial in an unmarked grave.

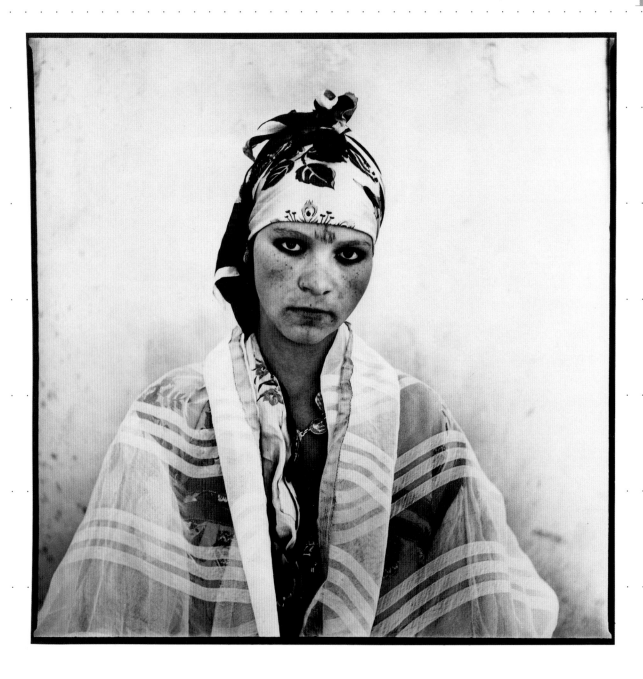

№. 0091

Femme Algérienne (Algerian Woman) 1960
TITLE DATE

Marc Garanger
PHOTOGRAPHER

San Francisco Museum of Modern Art. Accessions Committee Fund
COLLECTION

"In 1960, I was performing my military service in Algeria.

The French army had decided that the natives should have a French identity card to better regulate their transfer to "regroupment villages."

Since there was no civilian photographer, I was asked to photograph all of the people of the neighboring villages: Ain Terzine, Bordj Okliriss, le Mezdour, le Meglinine, Souk el Khremis.

I thus photographed close to 2000 people, primarily women, at the rate of 200 per day.

In each village, the inhabitants were summoned by the company commander. It was the faces of the women that really affected me. They had no choice. They were forced to remove their veils and let themselves be photographed. They had to sit on a stool, outdoors, in front of the white wall of a village.

I received their gaze at close range, first witness of their mute, violent protest.

I want to testify on their behalf."

—MARC GARANGER

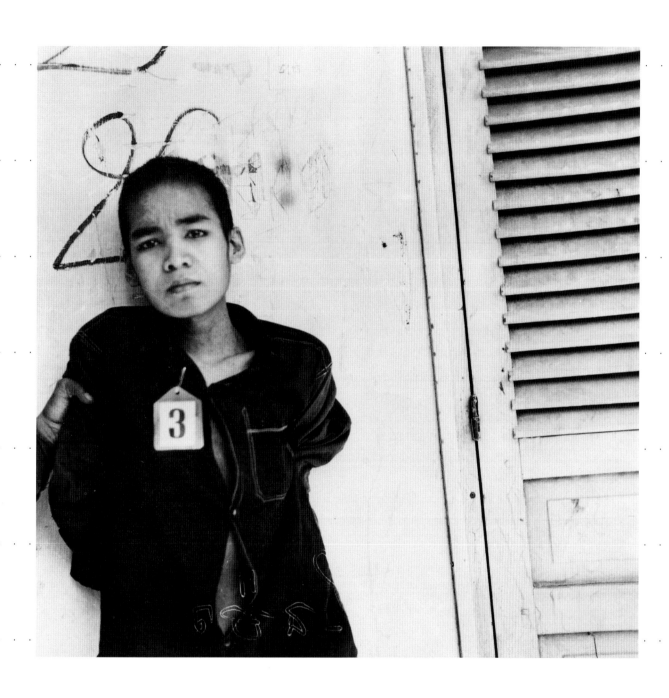

№. 0092

Untitled, from the Tuol Sleng Museum
of Genocide Photo Archive Project ca. 1976–79
TITLE DATE

Nhem Ein and assistants
PHOTOGRAPHER

San Francisco Museum of Modern Art. Accessions Committee Fund, 95.294
COLLECTION

Officially called the S-21 interrogation center, Tuol Sleng was a
Khmer Rouge torture camp in Phnom Penh and is now the site of a
genocide museum. In the mid-1970s alleged traitors were brought
here to "confess" before being taken to the Choeung Ek killing
field outside the capital. Chief photographer at the camp, Nhem
Ein had been trained in Shanghai and was a teenager when he and
his five apprentices made these photographs. Only seven of the
fifteen- to twenty-thousand prisoners held at Tuol Sleng are
known to have survived.

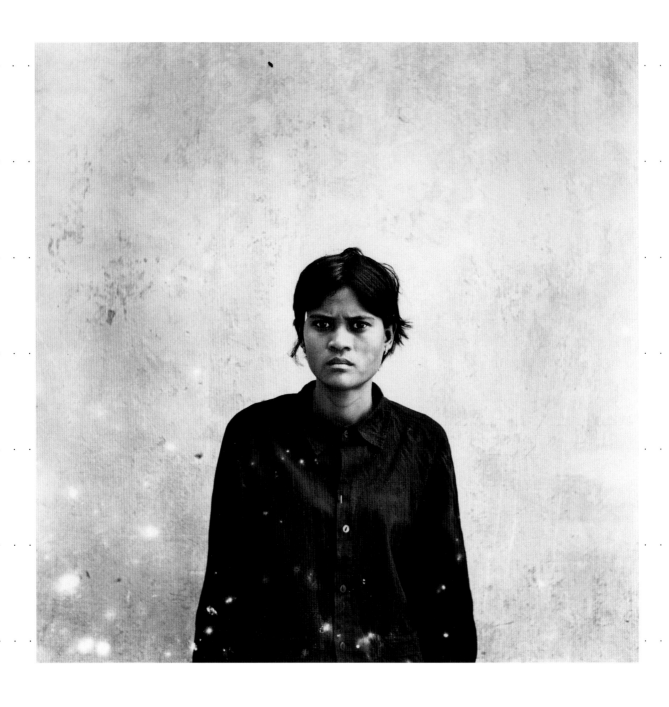

№. 0093

Untitled, from the Tuol Sleng Museum
of Genocide Photo Archive Project ca.1976–79
TITLE DATE

Nhem Ein and assistants
PHOTOGRAPHER

San Francisco Museum of Modern Art. Accessions Committee Fund, 95.295
COLLECTION

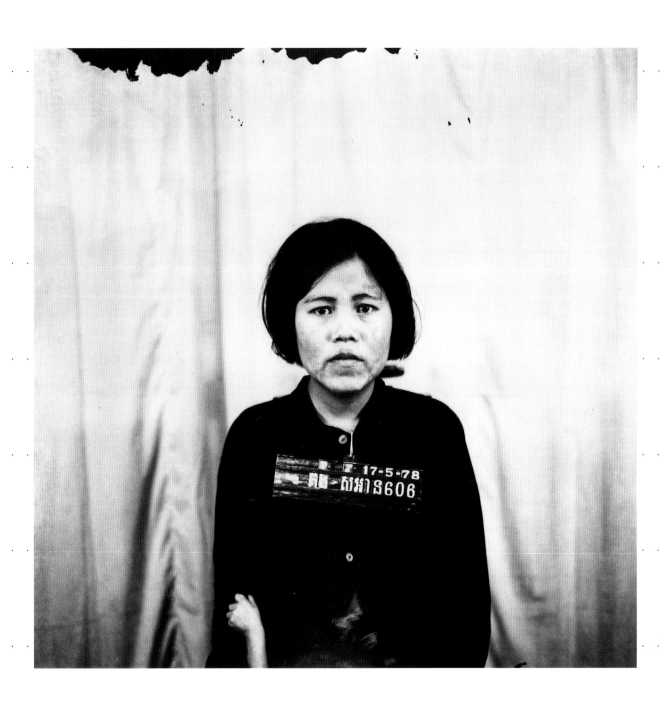

№. 0094

Untitled, from the Tuol Sleng Museum
of Genocide Photo Archive Project ca.1976–79
TITLE DATE
Nhem Ein and assistants
PHOTOGRAPHER

San Francisco Museum of Modern Art. Accessions Committee Fund, 95.293
COLLECTION

1
Unknown
*L'Empreinte de la main gauche
d'Arthur Joseph Mallet, né le 7 Mai
1885* (Print of the Left Hand of Arthur
Joseph Mallet, born May 7, 1885), n.d.
Collection of the Archives Historiques
et Musée de la Préfecture de Police,
Paris

2
J. T. Zealy
*"Renty," Congo. On Plantation of B. F.
Taylor. Columbia, South Carolina*, 1850
daguerreotype
3 ½ x 2 ½ in. (8.9 x 6.4 cm)
Collection of the Peabody Museum,
Harvard University

3
J. T. Zealy
*"Renty," Congo. B. F. Taylor. Esq.
Columbia, South Carolina*, 1850
daguerreotype
3 ½ x 2 ½ in. (8.9 x 6.4 cm)
Collection of the Peabody Museum,
Harvard University

4
J. T. Zealy
*"Drana," Country Born, Guinea.
Daughter of Jack. Plantation of B. F.
Taylor. Columbia, South Carolina*, 1850
daguerreotype
3 ½ x 2 ½ in. (8.9 x 6.4 cm)
Collection of the Peabody Museum,
Harvard University

5
J. T. Zealy
*"Drana," Country Born, Guinea.
Daughter of Jack. Plantation of B. F.
Taylor. Columbia, South Carolina*, 1850
daguerreotype
3 ½ x 2 ½ in. (8.9 x 6.4 cm)
Collection of the Peabody Museum,
Harvard University

6
Roger Fenton
Skeletons of Man and Male Gorilla,
ca. 1857
salted-paper print
13 ⁵⁄₁₆ x 10 ¹³⁄₁₆ in. (33.8 x 27.6 cm)
Collection of the Victoria and Albert
Museum

7
Sir Francis Galton
Criminal Composites, 1870s
albumen prints
from left: 2 ¼ x 1 ¾ in. (5.7 x 4.5 cm);
2 ¾ x 2 ¼ in. (7 x 5.7 cm); 2 ¼ x 1 ¾ in.
(5.7 x 4.5 cm)
Galton Papers, The Library, University
College London

8
Sir Francis Galton
Jewish Composites, 1870s
albumen prints
2 ¾ x 1 ⁹⁄₁₆ in. (7 x 4 cm) each
Galton Papers, The Library, University
College London

9
Sir Francis Galton
*Mr. Barton, Resident of Bethlem
Asylum*, 1870s
albumen print
3 ¹⁵⁄₁₆ x 2 ⅜ in. (10 x 6 cm)
Galton Papers, The Library, University
College London

10
Unknown
An Epileptic Boy, figure 14 of the book
*Criminal Man: According to the
Classification of Cesare Lombroso*, by
Gina Lombroso Ferrero, 1911
halftone lithograph
3 ⁵⁄₁₆ x 2 ⁵⁄₁₆ in. (8.4 x 5.9 cm)
Collection of the San Francisco
Museum of Modern Art

11
Unknown
Epileptiques, plate XV of the book
L'Homme criminel (Criminal Man),
by Cesare Lombroso, 1887
lithograph
9 x 5 ½ in. (23 x 14 cm)
Special Collections, The Library and
Center for Knowledge Management,
University of California, San Francisco

12
Guillaume-Benjamin Duchenne
[known as Duchenne de Boulogne]
*Icono-Photographique: Mécanisme de
la physionomie humaine, Fig. 58*
(Photographic Likeness: The
Mechanism of Human Facial
Expression, Fig. 58), 1854
gelatin-coated, salted-paper print
4 ¹¹⁄₁₆ x 3 ⅝ in. (11.9 x 9.2 cm)
Collection of the San Francisco
Museum of Modern Art. Gift of
Harry Lunn

13
Guillaume-Benjamin Duchenne
[known as Duchenne de Boulogne]
Plate illustration from the book
Mécanisme de la physionomie humaine
(The Mechanism of Human Facial
Expression), 1876
albumen print
10 ¼ x 6 ½ in. (26 x 17 cm)
Special Collections, The Library and
Center for Knowledge Management,
University of California, San Francisco

14
Alphonse Bertillon
Mensuration du crâne (au visage plein)
(Measurement of Skull [Full Face]), n.d.
Collection of the Archives Historiques
et Musée de la Préfecture de Police,
Paris

15
Alphonse Bertillon
*Tableau synoptique des traits phys-
ionomiques pour servir au relevé du
signalment descriptif* (Synoptic Table of
Facial Expressions for the Purpose of
Systematic Identification), n.d.
Collection of the Archives Historiques
et Musée de la Préfecture de Police,
Paris

16
D. D. Beatty and John T. Mason
*Chinese Photographed by D. D. Beatty
with Brief Biographical Descriptions by
John T. Mason, Justice of the Peace,
Downieville, California*, 1890
record book with albumen prints
7 ¹¹⁄₁₆ x 4 ¹³⁄₁₆ in. (19.5 x 12.2 cm)
Collection of the California Historical
Society Library, San Francisco

17
L. H. Heller
Donald McKay and Jack's Capturers,
1873
albumen print
2 ⅞ x 4 in. (7.4 x 10.2 cm)
Yale Collection of Western Americana,
Beinecke Rare Book and Manuscript
Library

18
Lt. Butterfield
*Leaders of the Hostile Indians at Pine
Ridge Agcy., S.D., During the Late
Sioux War: Chief Two Strike, Chief
Crow Dog, and Chief High Hawk*,
from *The Battle of Wounded Knee, a
Collection of Original Photographic
Prints of the Battle, the Leading
Participants on Both Sides, Gathering
and Burial of the Dead, and the Trial
of Chief Plenty Horses*, 1890–91
gelatin silver print
4 ¹⁵⁄₁₆ x 7 ³⁄₁₆ in. (12.6 x 18.3 cm)
Yale Collection of Western Americana,
Beinecke Rare Book and Manuscript
Library

19
Attributed to Felice A. Beato
Untitled (Gallows on which two of the
King of Delhi's sons were hanged for
having taken part in the murder of the
English residents at Delhi), 1857
albumen print
9 x 11 in. (22.9 x 27.9 cm)
Photography Collection, Harry
Ransom Humanities Research Center,
The University of Texas at Austin

20
Unknown
Insurgés non réclamés (Unclaimed
Insurgents), from a series of pho-
tographs of the Paris Commune, 1871
albumen print
7 ⁷⁄₉ x 10 ⅞ in. (19.8 x 27.6 cm)
Photography Collection, Harry
Ransom Humanities Research Center,
The University of Texas at Austin

21
United States War Department
*$100,000 Reward! The Murderer of
Our Late Beloved President, Abraham
Lincoln, Is Still at Large.*, 1865
printed sheet with three
albumen prints
23 x 12 in. (58.4 x 30.5 cm)
Collection of Albert H. Small

22
Alexander Gardner
Lewis Paine, April 27, 1865, 1865
albumen print
8 ¾ x 6 ⅞ in. (22.2 x 17.5 cm)
Gilman Paper Company Collection

23
Alexander Gardner
Conspirator Payne, 1865
albumen print
8 ¾ x 6 ⅞ in. (22.2 x 17.5 cm)
Collection of the San Francisco
Museum of Modern Art. Purchased
through a gift of Shawn Byers and the
Accessions Committe Fund, 97.44

24
Alexander Gardner
Lewis Payne, Lincoln Conspirator, 1865
modern gelatin silver print
9 ⅞ x 7 ⅞ in. (25.1 x 20 cm)
Collection of the Library of Congress

25
Alexander Gardner
*Coffins and Open Graves Ready for
Conspirators' Bodies at Right of
Scaffold, Washington, D.C., July 7, 1865*,
1865
modern gelatin silver print
7 ⅞ x 9 ⅞ in. (20 x 25.1 cm)
Collection of the Library of Congress

26
Brady Studio
Andersonville Still Life, 1866
albumen print
8 ¾ x 7 ½ in. (22.2 x 19.1 cm)
Gilman Paper Company Collection

27
Unknown
Jesse Woodson James, ca. 1870
tintype
3 ⅛ x 1 ⅞ in. (7.9 x 4.8 cm)
Collection of the National Portrait
Gallery, Smithsonian Institution

28
C. G. Glass, Coffeyville, Kansas
*Dalton Gang after the Coffeyville Bank
Robbery (from left: Dick Brodwell, Bill
Powers, Bob Dalton, Grat Dalton, and
Emmett Dalton)*, 1892
albumen print cabinet card
4 ¼ x 6 ½ in. (10.8 x 16.5 cm)
Collection of the Kansas State
Historical Society, Topeka, Kansas

29
Solomon D. Butcher
*Settlers Taking the Law into Their Own
Hands Cutting 15 Miles of the Brighton
Ranch Fence in 1885*, 1885
albumen print
6 ½ x 8 ½ in. (16.5 x 21.6 cm)
Solomon D. Butcher Collection,
Nebraska State Historical Society

30
Unknown
*Hand of Ching See Foo, the Chinese
Strangler Shot in Frisco in 1893*, 1893
gelatin silver print
9 ¾ x 7 ¾ in. (24.8 x 19.7 cm)
Courtesy of Stephen Wirtz Gallery,
San Francisco

31
Unknown
*Fan-tan Room and Table in Sing Hing
& Co., Ventura, CA*, ca. 1902
gelatin silver print
8 x 10 in. (20.3 x 25.4 cm)
Collection of the National Archives
and Records Administration—Pacific
Region (San Francisco)

32
Unknown
Description and Photos of San Joaquin County Prisoners: Eddie Hunt, Vagrant, Age 13, early 1900s
record book with gelatin silver prints
11 3/8 x 9 7/16 in. (28.9 x 24 cm)
Collection of the California Historical Society Library, San Francisco

33
Jacob Riis
Bandit's Roost, 39 1/2 Mulberry Street, ca. 1890
gelatin silver print
4 15/16 x 4 1/16 in. (12.5 x 10.3 cm)
Jacob A. Riis Collection, #101, Museum of the City of New York

34
Jacob Riis
The Short Tail Gang, Corlear's Hook, ca. 1889
gelatin silver print on printing-out paper
5 x 3 15/16 in. (12.7 x 10 cm)
Jacob A. Riis Collection, # 141, Museum of the City of New York

35
Jacob Riis (attributed to Richard Hoe Lawrence)
Chinatown Opium Joint, ca. 1890
albumen print
3 5/8 x 4 3/4 in. (9.2 x 12.1 cm)
Jacob A. Riis Collection, # M, Museum of the City of New York

36
Unknown
Plates 94–96 from the book *Professional Criminals of America* by Thomas Byrnes, 1886
heliotype
10 x 7 1/4 in. (25.4 x 18.4 cm) overall
Collection of Stanley B. Burns, M.D., and the Burns Archive

37
Jacob Riis
Untitled, ca. 1890/print ca. 1946–47
gelatin silver print
7 3/4 x 9 3/4 in. (19.7 x 24.8 cm)
Courtesy of Howard Greenberg Gallery

38
Unknown
Untitled, ca. 1890
wooden frame with gelatin silver prints
48 x 33 (121.9 x 83.8 cm) overall
Collection of Patterson Smith, Antiquarian Bookseller

39
Department of Corrections, San Quentin Prison
Untitled, 1913–1917
record book with gelatin silver prints
14 1/2 x 10 in. (36.8 x 25.4 cm)
Collection of the California State Archives

40
Unknown
Untitled, ca. 1900
record book with gelatin silver prints
13 x 11 in. (33 x 27.9 cm)
Private Collection

41
Unknown
$100 REWARD. . ., 1908
letterpress with gelatin silver print
11 7/8 x 8 3/4 in. (30.2 x 22.2 cm)
Collection of Peter E. Palmquist

42
Unknown
Untitled, ca. 1930
gelatin silver print mounted on card
6 x 3 1/4 in. (15.2 x 8.3 cm)
Collection of the San Francisco Museum of Modern Art. Accessions Committee Fund

43
Unknown
Three French Criminals, Accused of Passport Forgery, 1932
montage of three gelatin silver prints
6 1/4 x 3 3/4 in. (15.9 x 9.5 cm)
Collection of the San Francisco Museum of Modern Art. Members of Foto Forum, 96.511

44
Unknown
Untitled San Francisco Police Department album of prostitutes and vagrant women, 1945
record book with gelatin silver prints
7 1/4 x 11 1/2 in. (18.4 x 29.2 cm)
Private Collection

45
Unknown, possibly Alphonse Bertillon
Assassinat du jeune Grégoire Pierre dit le "Petit Pierre," le 14 Décembre, 1896: "Cité Vanneau—Endroit où l'enfant a été trouvé" (Assasination of Young Grégoire Pierre, called "Little Pierre," December 14, 1896: "Vanneau—Place where the child was found"), 1896
gelatin silver print
7 1/16 x 5 1/8 in. (17.9 x 13 cm)
Collection of Gérard Lévy, Paris

46
Unknown
Assassinat de Botelin Valentine, 14.9.04, 1904
Collection of the Archives Historiques et Musée de la Préfecture de Police, Paris

47
Unknown
"...found in bottom of freight...shaft at Marmon Auto Co....Employed as night watchman...145th St...near 8th Avenue...", ca. 1920
gelatin silver print
6 5/8 x 9 in. (16.8 x 22.9 cm)
Collection of Glenn Spellman Fine Art Photography, New York

48
Unknown
Affaire de Puteaux (Seine), Assassinat de Mme. Langlois, n.d.
10 3/8 x 7 3/8 in. (26.4 x 18.7 cm)
Collection of the Archives Historiques et Musée de la Préfecture de Police, Paris

49
Unknown
Assassinat de Lamarre, 7, rue Etienne Dolet au Kremlin Bicêtre, 11.12.97, 1897
Collection of the Archives Historiques et Musée de la Préfecture de Police, Paris

50
Unknown
Assassinat de M. Grimbal, charbonnier, 31 rue Chaptal, Levallois-Perret, 28.5.97, 1897
Collection of the Archives Historiques et Musée de la Préfecture de Police, Paris

51
Unknown
Affaire de la rue Erard No. 8, Assassinat de Mme. Veuve Noyer, n.d.
8 3/4 x 11 3/8 in. (22.2 x 28.9 cm)
Collection of the Archives Historiques et Musée de la Préfecture de Police, Paris

52
Unknown
Crime de la rue Bouchardon (Madame Daly), n.d.
Collection of the Archives Historiques et Musée de la Préfecture de Police, Paris

53
Dr. Petouraud
Hôpital de la Grange Blanche, 14/9/34: Tatouage d'un ancien du Bataillon disciplinaire d'Afrique (Maroc): "Souviens toi" (Grange Blanche Hospital, 9/14/34: Tattoo of an elder from the disciplinary batallion of Africa (Morocco): "Remember"), 1934
autochrome
3 9/16 x 2 9/16 in. (9 x 6.5 cm)
Collection of Gérard Lévy, Paris

54
Dr. Petouraud
Prison de Saint Pothin, 9/1/34: Dos tatoué de scène de bordel et la devise des anarchistes: "Ni Dieu ni Maître" (Saint Pothin Prison, 1/9/34: Back tattooed with a brothel scene and the motto of anarchists: "Neither God nor Master"), 1934
autochrome
2 9/16 x 3 9/16 in. (6.5 x 9 cm)
Collection of Gérard Lévy, Paris

55
Dr. Petouraud
Prison de Saint Pothin, 19/1/34: Portrait, 1934
autochrome
2 9/16 x 3 9/16 in. (6.5 x 9 cm)
Collection of Gérard Lévy, Paris

56
Dr. Petouraud
Prison de Saint Pothin, 20/1/34: Bras d'un souteneur: "Mort aux femmes infidèles" (Saint Pothin Prison, 1/20/34: Arm of a pimp: "Death to unfaithful women"), 1934
autochrome
3 9/16 x 2 9/16 in. (9 x 6.5 cm)
Collection of Gérard Lévy, Paris

57
Eugène Atget
Untitled, ca. 1925
albumen print on printing-out paper
5 5/16 x 8 7/16 in. (13.5 x 21.4 cm)
Photography Collection; Miriam and Ira D. Wallach Division of Art, Prints, and Photographs; The New York Public Library; Astor, Lenox, and Tilden Foundations

58
Eugène Atget
Versailles, femme et soldat, maison close. Mai 1921 (Versailles, Woman and Soldier, Brothel. May 1921), 1921
albumen print on printing-out paper
8 7/16 x 5 5/16 in. (21.4 x 13.5 cm)
Photography Collection; Miriam and Ira D. Wallach Division of Art, Prints, and Photographs; The New York Public Library; Astor, Lenox, and Tilden Foundations

59
Unknown
Photos of Chinese Opium Smokers in There [sic] *Dens in China Town in 1889,* page from *The Jesse Brown Cook Scrapbooks Documenting San Francisco History and Law Enforcement,* ca. 1910–35
scrapbook with gelatin silver prints
11 3/4 x 10 in. (29.8 x 25.4 cm) overall
Collection of The Bancroft Library, University of California, Berkeley

60
Unknown
March 21/22: Ernest Long Chief Engineer on the Steamship Rose City Was Arrested for Impersonating a Woman, page from *The Jesse Brown Cook Scrapbooks Documenting San Francisco History and Law Enforcement,* ca. 1910–35
scrapbook with gelatin silver prints
13 5/8 x 9 in. (34.6 x 22.9 cm) overall
Collection of The Bancroft Library, University of California, Berkeley

61
Unknown
Lynching of Thurmond and Holmes, San Jose, Calif., Nov. 26, 1933, 11:25 p.m., 1933
gelatin silver print
3 1/2 x 5 1/2 in. (8.9 x 14 cm)
Collection of the California Historical Society, San Francisco

62
Unknown
Same Parade, the Hole in the Wall the Bomb Made, detail of page from *The Jesse Brown Cook Scrapbooks Documenting San Francisco History and Law Enforcement,* ca. 1910–35
scrapbook with gelatin silver print
13 5/8 x 9 in. (34.6 x 22.9 cm) overall
Collection of The Bancroft Library, University of California, Berkeley

63
Tom Howard
The Electrocution of Ruth Snyder, 1928
gelatin silver print
4 x 4 in. (10.2 x 10.2 cm)
Collection of the San Francisco
Museum of Modern Art. Accessions
Committee Fund, 96.428

64
Unknown
Marie Cirenchia, Confessed Murderess,
1920
bromide silver print
8 x 7 ½ in. (20.3 x 19 cm)
Thomas Walther Collection, New York

65
International News Photos
*Scene of Dutch Schultz Shooting at
the Palace Bar and Grill, Newark,
New Jersey*, 1935
gelatin silver print
10 x 8 in. (25.4 x 20.3 cm)
Courtesy of UPI/Corbis-Bettmann

66
Unknown
Untitled (Abe Reles, deceased, Half
Moon Hotel, Coney Island, New York),
1941
gelatin silver print
8 x 10 in. (20.3 x 25.4 cm)
Collection of the New York City
Municipal Archives

67
Unknown
Untitled, ca. 1930s
gelatin silver print
8 x 10 in. (20.3 x 25.4 cm)
Collection of the New York City
Municipal Archives

68
Unknown
*Hoover and Clayton Moore (The Lone
Ranger)*, n.d.
gelatin silver print
7 ¼ x 9 in. (18.4 x 22.9 cm)
Courtesy FBI

69
Unknown
George R. "Machine Gun" Kelly, n.d.
gelatin silver print
11 ⅛ x 9 ¹⁄₁₆ in. (28.3 x 23 cm)
Courtesy FBI

70
Unknown
*Bonnie Parker, the Gun Moll of
the 1930s*, n.d.
gelatin silver print
10 x 8 in. (25.4 x 20.3 cm)
Collection of Stanley B. Burns, M.D.,
and the Burns Archive

71
International News Photos
George "Baby Face" Nelson, 1934
gelatin silver print
10 x 8 in. (25.4 x 20.3 cm)
Collection of Stanley B. Burns, M.D.,
and the Burns Archive

72
Weegee (Arthur Fellig)
*Booked on Suspicion of Killing a
Policeman*, 1939
gelatin silver print
15 ⅝ x 10 ¹¹⁄₁₆ in. (39.7 x 27.1 cm)
Collection of the San Francisco
Museum of Modern Art, 78.53

73
Weegee (Arthur Fellig)
Untitled, ca. 1940s
gelatin silver print
7 ½ x 9 ⅝ in. (19 x 24.4 cm)
Collection of the Museum of the City
of New York, Museum purchase

74
Weegee (Arthur Fellig)
Untitled, ca. 1940s
gelatin silver print
7 ⅝ x 9 ½ in. (19.4 x 24.1 cm)
Collection of the Museum of the City
of New York, Museum purchase

75
John Gutmann
The Killer, 1948
gelatin silver print
10 ¹⁄₁₆ x 12 ¾ in. (25.6 x 32.4 cm)
Courtesy of the artist and Fraenkel
Gallery, San Francisco

76
Unknown
James Earl Ray, n.d.
gelatin silver print, copy after
photomontage
7 ¼ x 9 in. (18.4 x 22.9 cm)
Courtesy FBI

77
Unknown
*TNT Demolition Block Showing Hole
to Acommodate a Detonator*, n.d.
gelatin silver print
7 ¼ x 9 in. (18.4 x 22.9 cm)
Courtesy FBI

78
Unknown
Kurt Frederick Ludwig, 1940
gelatin silver print
9 x 7 ¼ in. (22.9 x 18.4 cm)
Courtesy FBI

79
Harold E. Edgerton
Untitled, 1944
gelatin silver print
10 x 10 in. (25.4 x 25.4 cm)
Collection of Arlette and Gus Kayafas

80
Harold E. Edgerton
Untitled, 1944
gelatin silver print
10 x 10 in. (25.4 x 25.4 cm)
Collection of Arlette and Gus Kayafas

81
Mike Mandel and Larry Sultan
Untitled, from the project *Evidence*,
1977
gelatin silver print
7 ¼ x 8 ½ in. (18.4 x 21.6 cm)
Collection of the San Francisco
Museum of Modern Art. Purchased
through a gift of Mary and Thomas
Field, Accessions Committee Fund,
93.43.19

82
Mike Mandel and Larry Sultan
Untitled, from the project *Evidence*,
1977
gelatin silver print
9 ½ x 7 ⅝ in. (24 x 19.4 cm)
Collection of the San Francisco
Museum of Modern Art. Purchased
through a gift of Mary and Thomas
Field, Accessions Committee Fund,
93.43.22

83
Unknown
Reenactment, 1968
gelatin silver print
10 x 8 in. (25.4 x 20.3 cm)
Collection of the California State
Archives

84
Harold Burba, for the Los Angeles
Fire Department
Aftermath, 1968
gelatin silver print
7 ⅝ x 7 ½ in. (19.4 x 19.1 cm)
Collection of the California State
Archives

85
Unknown
Untitled, 1966
gelatin silver print
7 x 9 in. (17.8 x 22.9 cm)
Collection of the National Archives,
Washington, D.C.

86
Unknown
Untitled photo of a demonstration at
the Stanford Research Institute, 1969
gelatin silver print
5 ¾ x 8 ⅜ in. (14.6 x 21.3 cm)
Collection of Andrew Moss

87
Dave Gatley
*Ghostly view through night-vision
infrared scope shows nearly a dozen
illegals caught between horseback-
mounted and truck units of border
police.*, 1995
gelatin silver print
10 ⁷⁄₁₆ x 11 ½ in. (26.5 x 29.2 cm)
Collection of the San Francisco
Museum of Modern Art. Accessions
Committee Fund

88
United Press International
Fingerprints of Che Guevara, 1967
gelatin silver print
7 ⅝ x 9 ¾ in. (19.4 x 24.8 cm)
Collection of the San Francisco
Museum of Modern Art, 96.334

89
Gene O'Donnell, FBI
Untitled, 1994
gelatin silver print
11 ¼ x 15 ⅜ in. (28.6 x 39 cm)
Courtesy of the Investigative and
Prosecutive Graphic Design Unit, FBI

90
Howard Sochurek, *Life* magazine
Dead Bandit, 1954
gelatin silver print
14 x 11 ¼ in. (35.6 x 28.6 cm)
Collection of the San Francisco
Museum of Modern Art. Accessions
Committee Fund, 96.320. Courtesy
of Time Inc.

91
Marc Garanger
Femme Algérienne (Algerian Woman),
1960
gelatin silver print
9 ⁷⁄₁₆ x 9 ⁷⁄₁₆ in. (24 x 24 cm)
Collection of the San Francisco
Museum of Modern Art. Accessions
Committee Fund

92
Nhem Ein and assistants
Untitled, from the Tuol Sleng Museum
of Genocide Photo Archive Project,
ca. 1976–79
gelatin silver print
10 1/4 x 10 1/4 in. (26 x 26 cm)
Collection of the San Francisco
Museum of Modern Art. Accessions
Committee Fund, 95.294

93
Nhem Ein and assistants
Untitled, from the Tuol Sleng Museum
of Genocide Photo Archive Project,
ca. 1976–79
gelatin silver print
10 ¼ x 10 ¼ in. (26 x 26 cm)
Collection of the San Francisco
Museum of Modern Art. Accessions
Committee Fund, 95.295

94
Nhem Ein and assistants
Untitled, from the Tuol Sleng Museum
of Genocide Photo Archive Project,
ca. 1976–79
gelatin silver print
10 ¼ x 10 ¼ in. (26 x 26 cm)
Collection of the San Francisco
Museum of Modern Art. Accessions
Committee Fund, 95.293